David Stern
The American Years
(1995–2008)

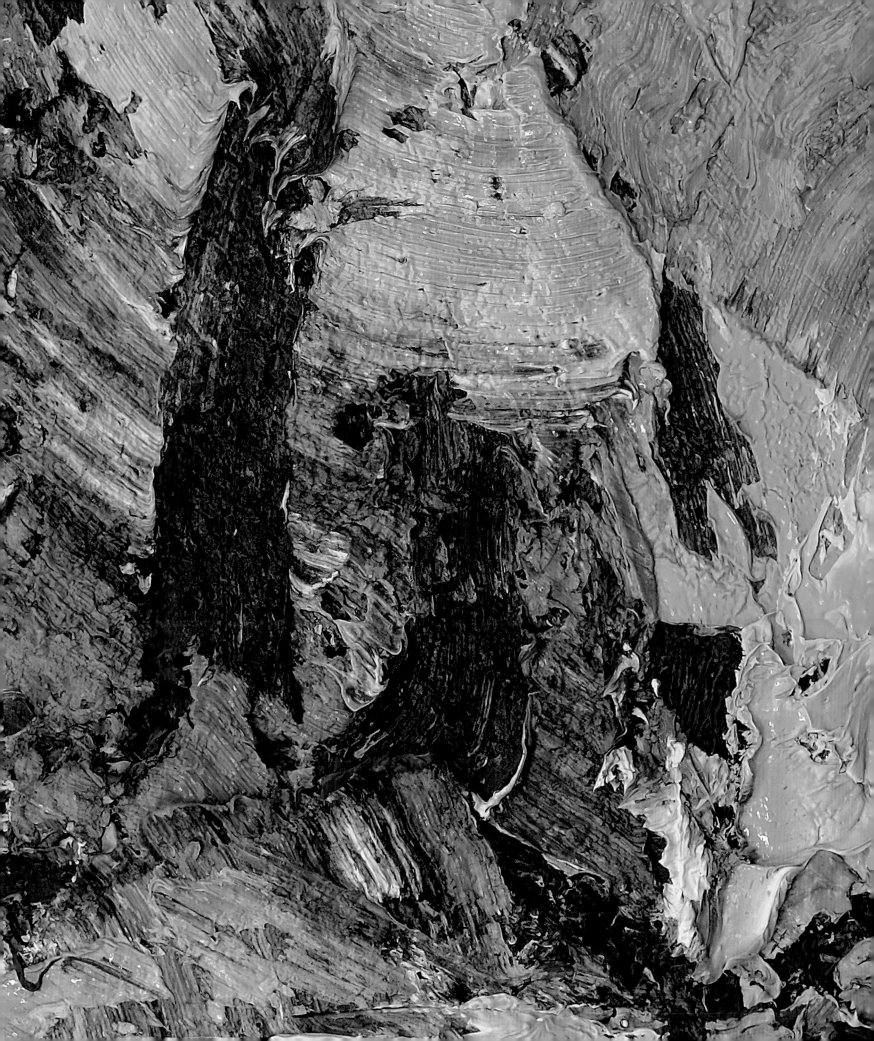

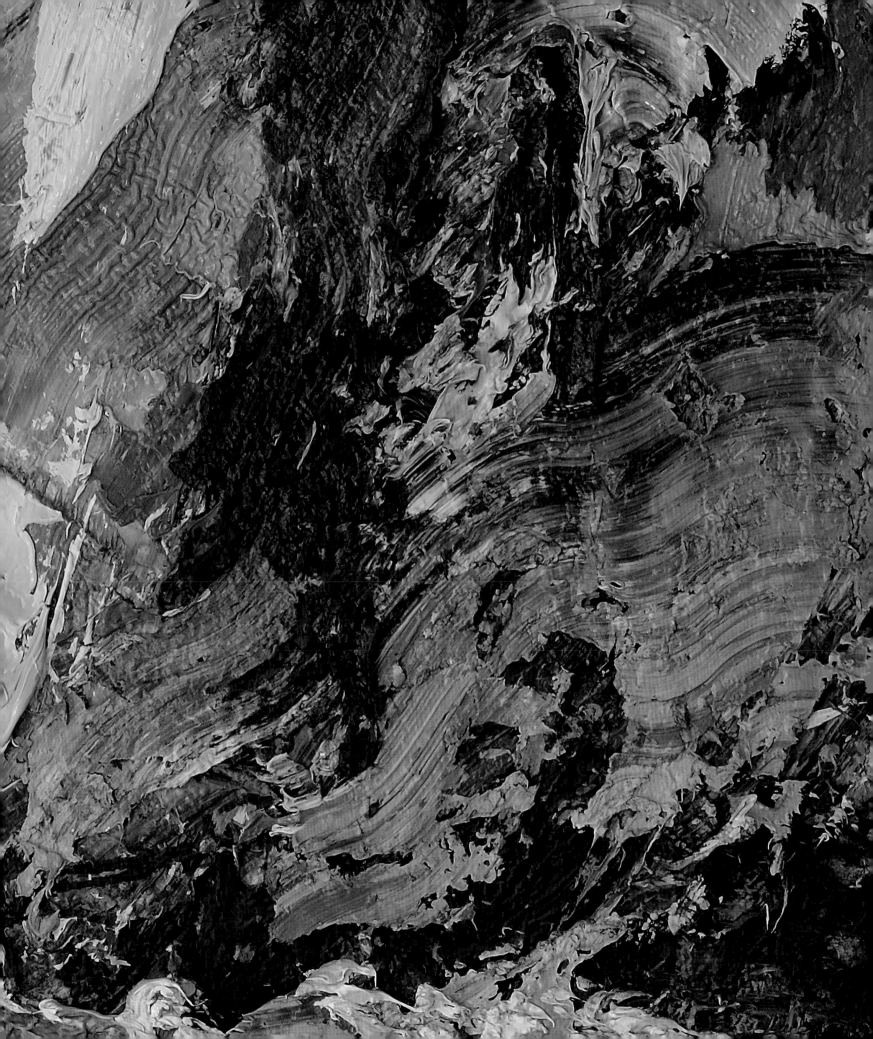

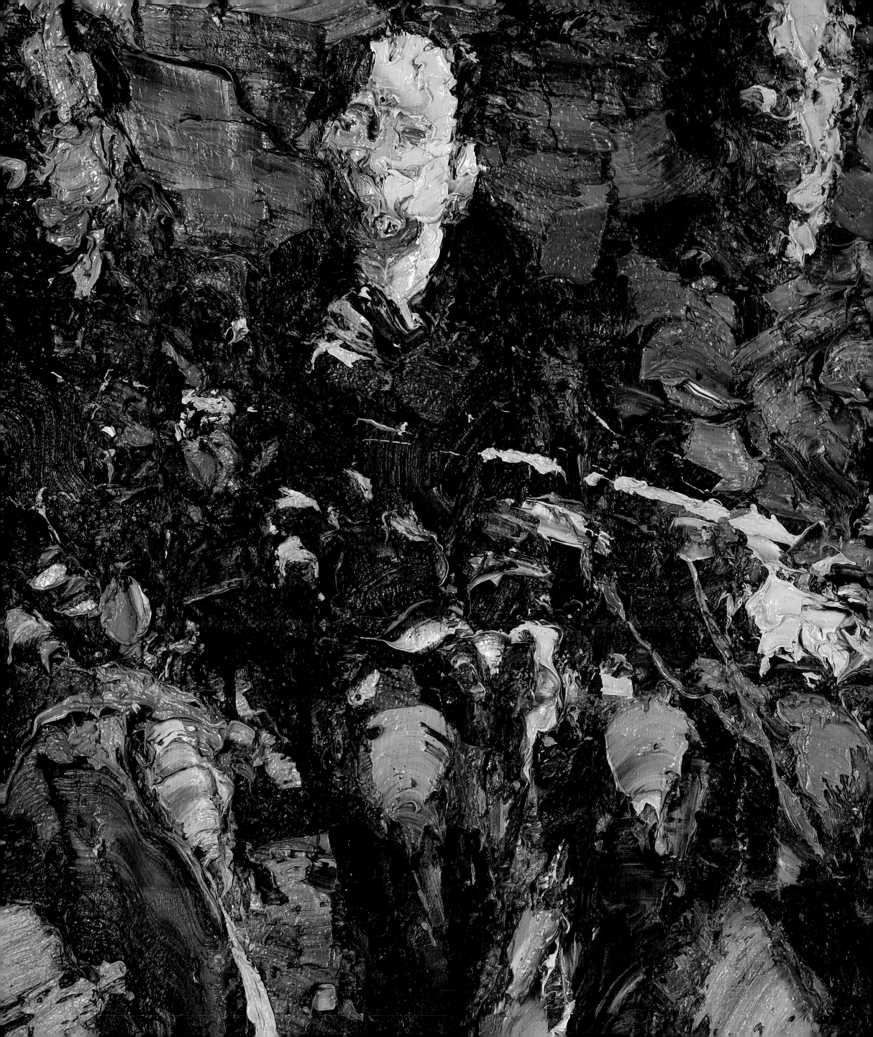

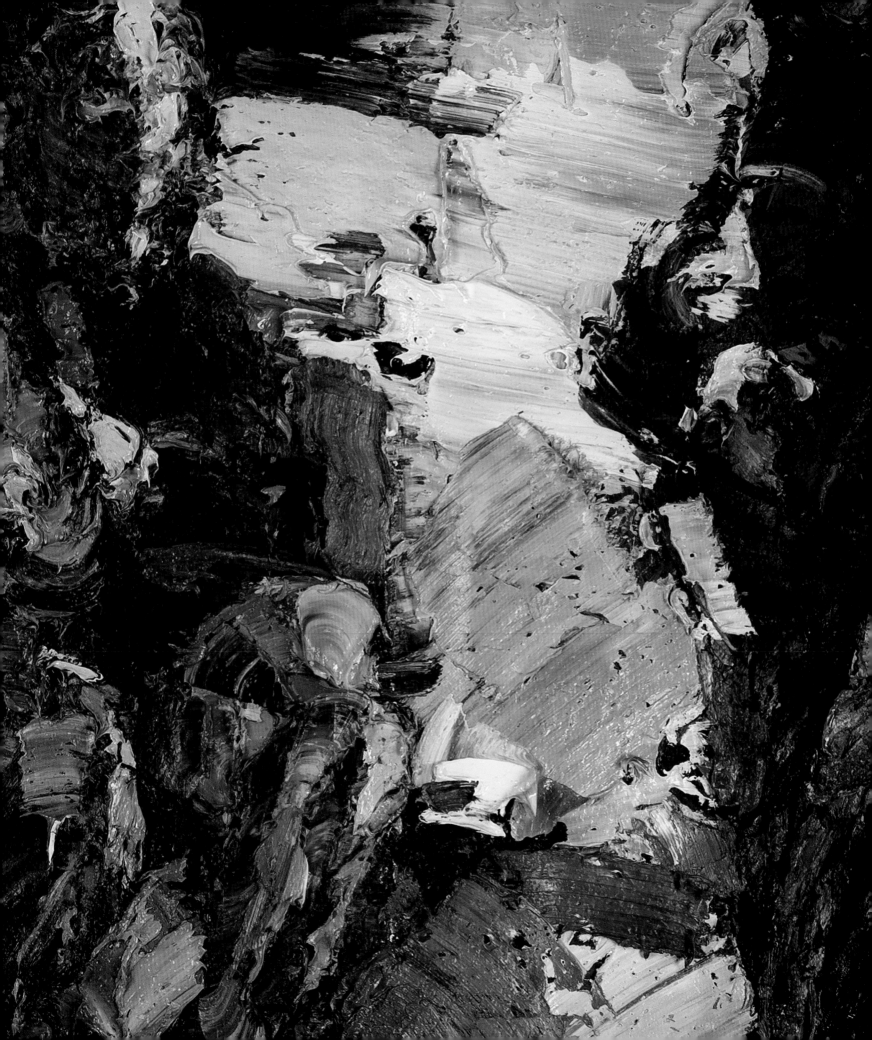

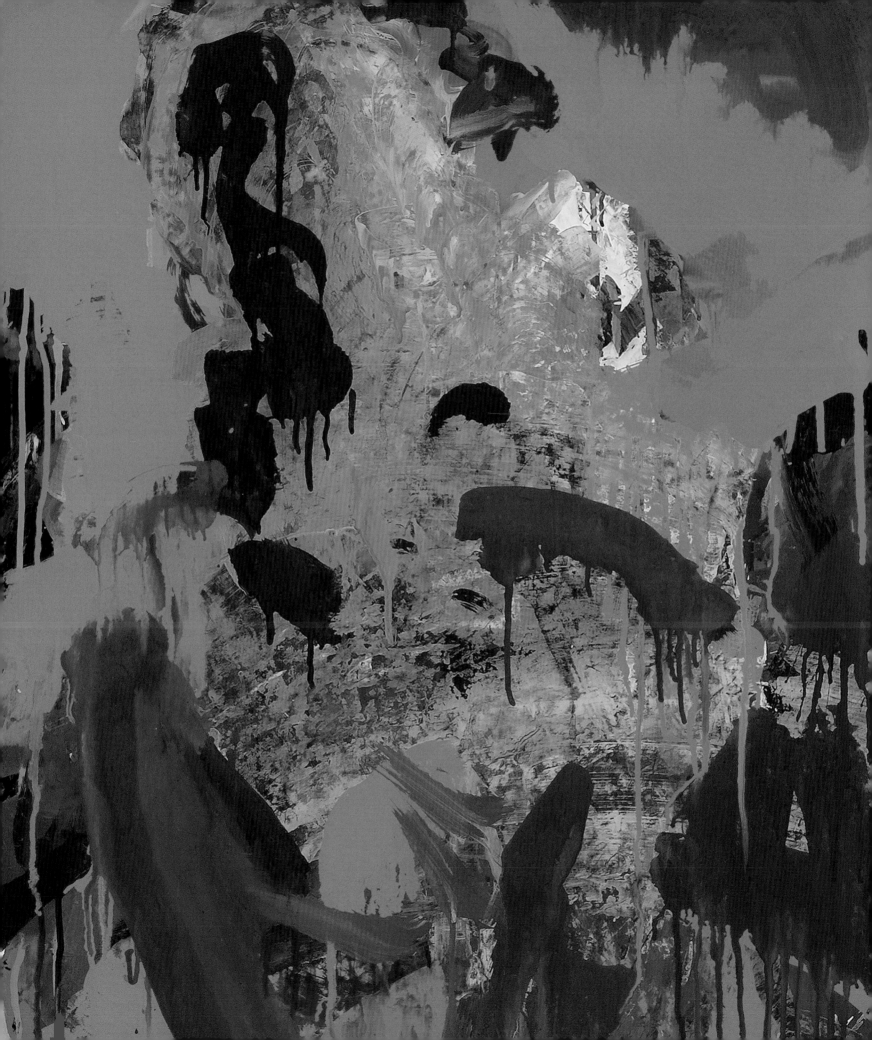

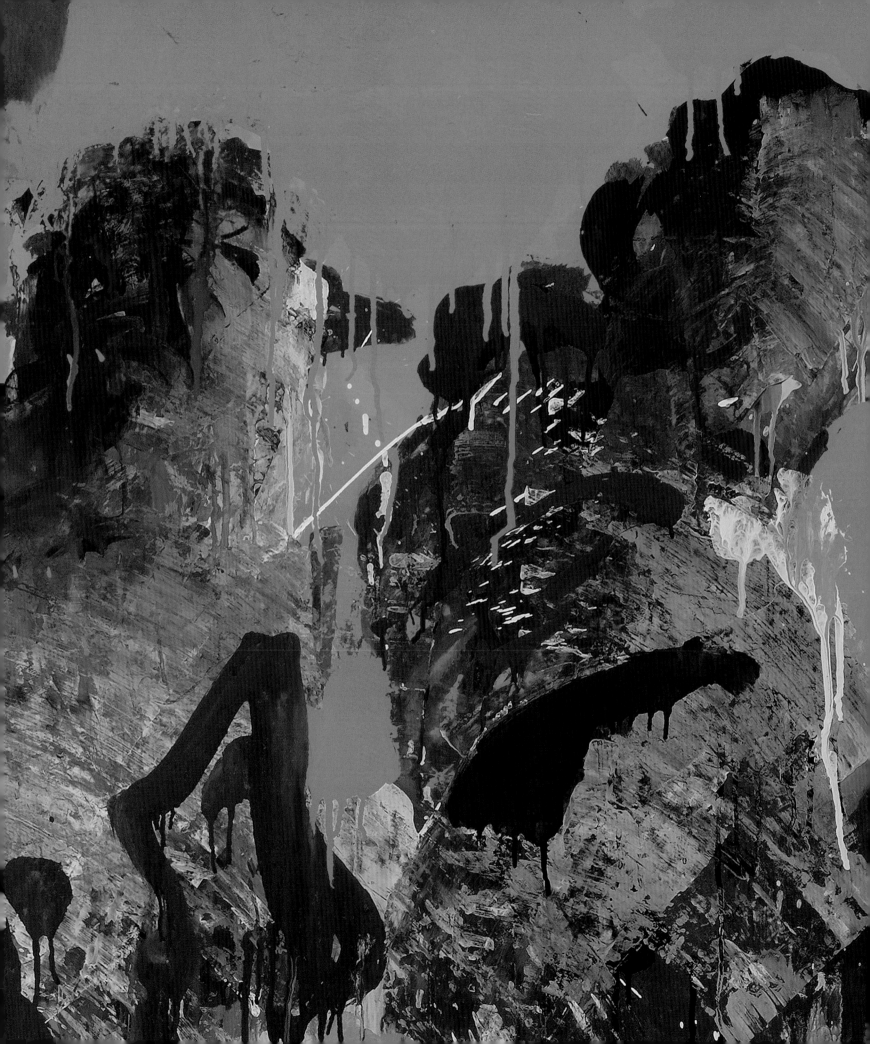

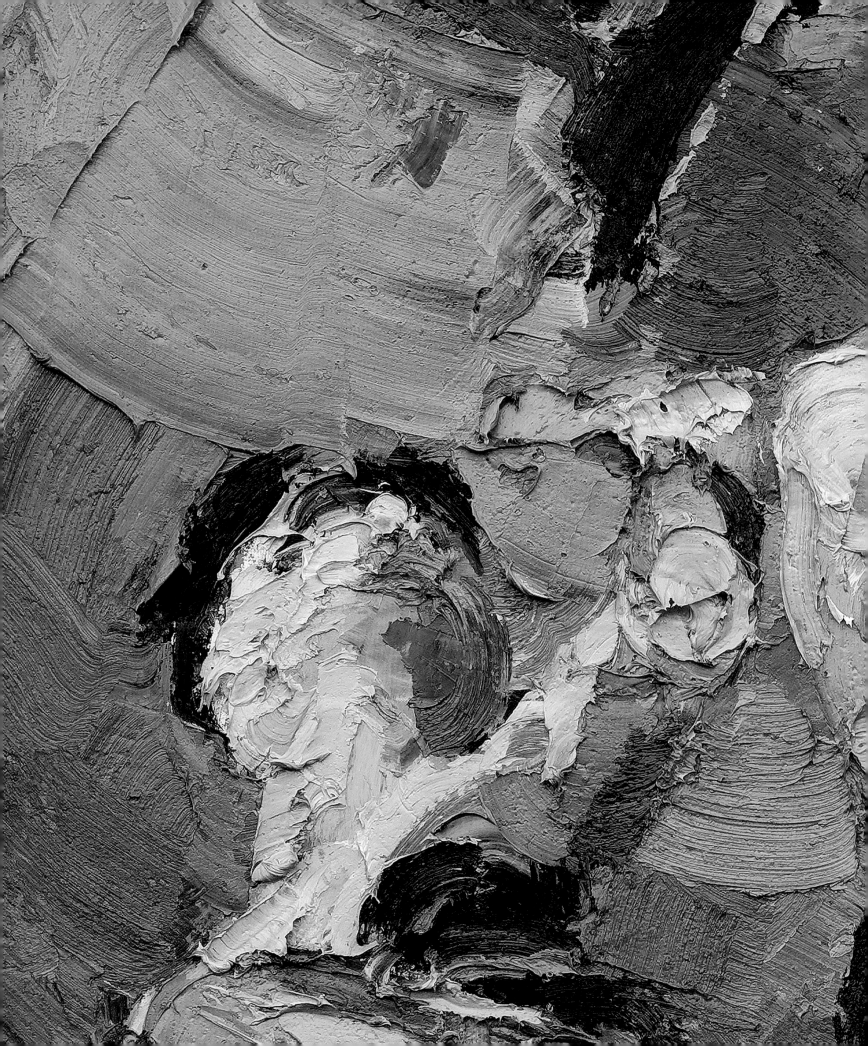

12

This catalogue is published in conjunction with the concurrent exhibitions

David Stern: The American Years (1995–2008)

Yeshiva University Museum, New York, September 18, 2008 – February 8, 2009

Alexandre Hogue Gallery of the University of Tulsa, Oklahoma, October 30 – November 28, 2008

and national tour until 2012.

Curated by Karen Wilkin, New York

The exhibition is under the patronage of the Consul General of the Federal Republic of Germany Horst Freitag.

The exhibition is a sponsored project of the New York Foundation for the Arts, with partial funding from Rivki and Lindsay Rosenwald and Otto Brandl Transport GmbH, Cologne, Germany. Further funding was provided by Materials for the Arts, New York; Agus Family; C Funding; David Israel; Marci and Mike Weiss; Victor and Esther Schnitzer; James Garfinkel; Michelle and Eli Salig; Steve Orlikoff; and an anonymous donor.

ISBN: 978-0-615-21645-4

All photographs by Malcolm Varon, New York, except pp. 34–35 (Wim Cox, Cologne, Germany); pp. 4–5, 8–9, 76–77, 129, 152–55 (Jan Tepass, Cologne, Germany); pp. 10, 20, 25, 47–49, 51, 53, 55, 61, 65, 67, 69, 71, 79, 81–83, 89–91, 94–95, 113 (Les Helmers, New York); p. 30 (Eric Feinblatt, New York); and pp. 41, 73–75, 122–23 (supplied by private collectors).

Color correction and print preparation of all images by Malcolm Varon, New York

Edited by Rachel Stern, New York

Designed by Hal Kugeler, Chicago

Printed in Bruges, Belgium, by Die Keure

The text in this catalogue was set in Myriad, a humanist sans serif design that was the product of a collaboration between Robert Slimbach and Carol Twombly. Myriad was originally released in 1992 by Adobe.

COVER
Bryant Park (detail)
2008
Oil on cotton
58 × 75 inches
Artist's collection
See also pp. 168–69.

PAGES 2–3
Skypiece (detail)
1996
Oil on cotton
55 × 47 inches
Artist's collection
See also p. 42.

PAGES 4–5
Square Times (Common Ground) (detail)
2000
Oil on Cotton
65 × 81 inches
HGB Germany
See also pp. 76–77.

WPAGES 6–7
Coming Home (detail)
2006
Mixed media on paper
38 × 52 inches
Artist's collection
See also pp. 138–39.

PAGES 8–9
Cherry Pickers (detail)
2005
Oil on cotton
74 × 58 inches
Private collection
See also p. 129.

FRONTISPIECE PAGE 10
Joe
1999
Oil on cotton
28 × 16 inches
Rabinowich collection

YESHIVA UNIVERSITY MUSEUM

NYFA
New York Foundation for the Arts

materials for the arts
NYC DEPARTMENT OF CULTURAL AFFAIRS

Yeshiva University Museum

David Stern
The American Years (1995–2008)

Curator
Karen Wilkin

Conversation
David Stern
Karen Wilkin

Essay
Lance Esplund

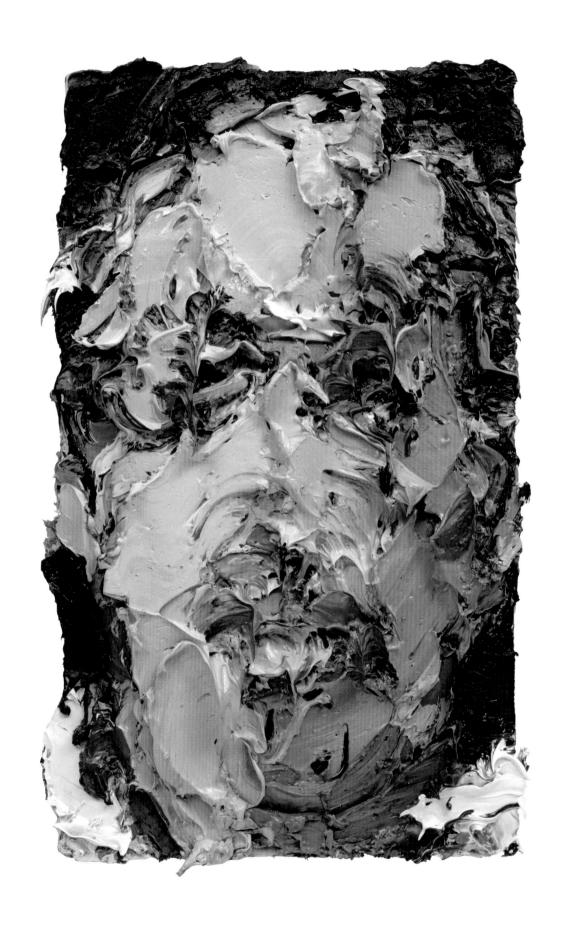

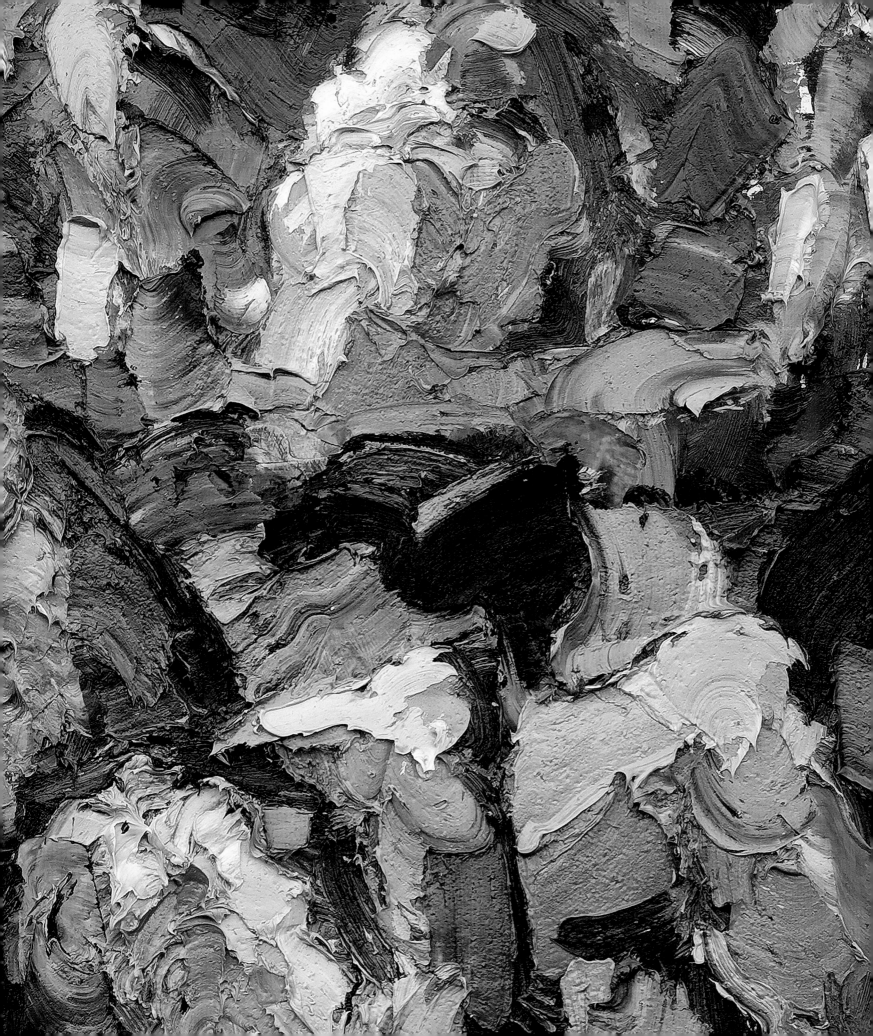

Contents

14

Hallel
1995
Oil on cotton
67 × 31 inches
Stern collection

Introduction

David Stern: The American Years, 1995–2008

David Stern's history as an artist encapsulates, in many ways, the wholly modern notion of the "artist without borders" whose work reflects the multivalent experience of an increasingly globalized world. Born and educated as a painter in Germany, a German Jew in a post-World War II society, Stern has lived and worked in New York since 1995. Since his arrival, he has been fascinated by his encounters with an intensely urban place defined by its energy, crowding, speed, and cosmopolitanism.

Stern's relation to the visible world and his ways of handling paint have remained constant. He can be described, with equal accuracy, as a figurative painter who freely reconstitutes his perceptions with emphasis on the materiality of his medium or as an expressionist who discovers suggestive images by exploring the physical qualities of paint. Stern constructs his pictures with generous swipes of thick pigment, building up dense surfaces that attest to the prolonged incubation period of every picture, its slow evolution, and history of change.

The viscosity and sensuality of pigment are so potent that, at first, the fact of paint seems to take precedence over any other concerns; confronted by one of Stern's voluptuously inflected canvases, we seem to recapitulate his manipulation of his malleable, responsive material. Over time, however, the lush patches of paint begin to coalesce into fleeting images, subside into "pure" pictorial incident, and then declare their coherence and allusiveness, once again.

Since his arrival in New York, Stern has dealt mainly with urban themes, working (until recently) in series that develop the permutations of, for example, people moving through crowded streets, gathering in public places, taking public transportation, and, in one subtle and memorable group of pictures, coming together in the aftermath of September 11th.

He has also painted portrait heads and full length figures, again, often in series, probing and re-probing variations in pose, gesture, and the figure's relation to the canvas, in repeated images of his admirers, friends, and family. Studies and related drawings enlarge our sense of Stern's process.

It seems an appropriate time, both in terms of Stern's development as a painter and in terms of the gradual erosion of national differences that characterizes our era, to examine the works he has made since moving to New York. This survey exhibition, spanning 1995–2008, reunites key paintings and related paper works from Stern's major series of these years, along with recent "independent," non-serial works.

Bringing together this representative group of Stern's paintings and drawings made in New York raises interesting questions about, among other things, the nature of perception, both of actuality and of painted fictions, about identity, and about the painter's relation to his physical, social, and political surroundings. The potency of Stern's work speaks for itself, but in addition to its aesthetic merit, the resulting exhibition is a fascinating document of the responses of a present day, sophisticated "art world immigrant" to a constantly changing international environment.

Karen Wilkin

Acknowledgements

Chelsea Screening
2005
Oil on cotton
81 × 71 inches
Artist's collection

I would like to thank all the lenders to this exhibition for generously making their works by David Stern available to a wider audience. I am indebted to the New York Studio School of Painting, Drawing, and Sculpture for permission to use an interview with the artist, presented as part of the school's 2007 lecture series, as the basis for the transcribed conversation included in this catalogue. Lance Esplund is owed many thanks for his illuminating contribution. Finally, I am immensely grateful to David Stern for being so generous with his time and to Rachel Stern, a tireless, ideal collaborator whose efforts and expertise made this exhibition possible. **KW**

Most importantly, I thank all the lenders, who made this exhibition possible by generously making their works available.

I also thank:

Karen Wilkin, who originated the idea for this exhibition a few years back and has been a source of support and care for my work ever since she laid first eyes on it in 1998;

My wife Rachel Stern, who worked tirelessly to overcome the many obstacles to make this exhibition possible. Her deep commitment to me and my work kept me going, against all odds;

Those who worked on this catalogue and made it as beautiful as it is. Lance Esplund for his insights represented in his essay, Malcolm Varon for his painstaking work on the reproductions, Hal Kugeler for his intuitive design, and Michael Sakkali and the staff at Die Keure, especially Stijn Blontrock and Wouter Rummens.

Sylvia Herskowitz for her enthusiasm and persistence in her vision for the exhibition, Reba Wulkan, Rachel Lazin, Jody Heher, Gabriel M. Goldstein and the entire staff of the Yeshiva University Museum in New York, Susan Dixon and Mark Lewis and the entire staff of the Alexandre Hogue Gallery of the University of Tulsa, Oklahoma.

There are many people whose personal involvement has been important for these past 15 years and I'd like to thank all of them:

HGB, Joachim Graf, Diter Frowein, Volker Offenbächer, Dr. Andreas Brand, and Coco Ortner, who have been true patrons and continue to be close followers of my work from Germany.

Dr. Lindsay Rosenwald, David Jaroslawicz, Elliott Gibber, Harry Skydell, Sam Steinberg and Mark Karasick, whose support for me and my work has been crucial here in New York.

Ronald Fagan, Walter Hus, Lance Esplund, Berel Rodal, Neil Herskowitz, Marvin Hayes, and Moshe Weiss, whose continued friendship has been a source of strength for me over the years.

Rabbi Allen Schwartz, Rabbi Ari Berman, Rabbi Tsvi Blanchard, Rabbi Albert Plotkin, Rabbi Ozer Glickman, Dr. Mark Gross, Prof. Dr. Arthur Jacobson, Dr. Eve Hartheimer, Shelley Nagar, Dr. Elizabeth Barker, Sam Rippner, Dr. Carmen C. Bambach, Chris Begley, Dr. Hans-Jürgen and Lizabeth Heimsoeth, Monica Strauss, Isabelle Dervaux, Dr. Ori Z. Soltes, Dr. Andrew Kaplan, Dr. David Weinstein, James Garfinkel, Raanan Agus, Mark Segall, David Israel, Michael Lewittes, Lisa Lipkin, Richard Shabeiro, Fred Helm, Graham Nickson, Steve Orlikoff, Eli Salig, Victor Schnitzer, Marvin Sternberg, William Wegman, Dr. Pia Schneider and Prof. Dr. Rainer Lademann, Mike Weiss and others who prefer to remain anonymous, who have been a well of wisdom, friendship and support. **DS**

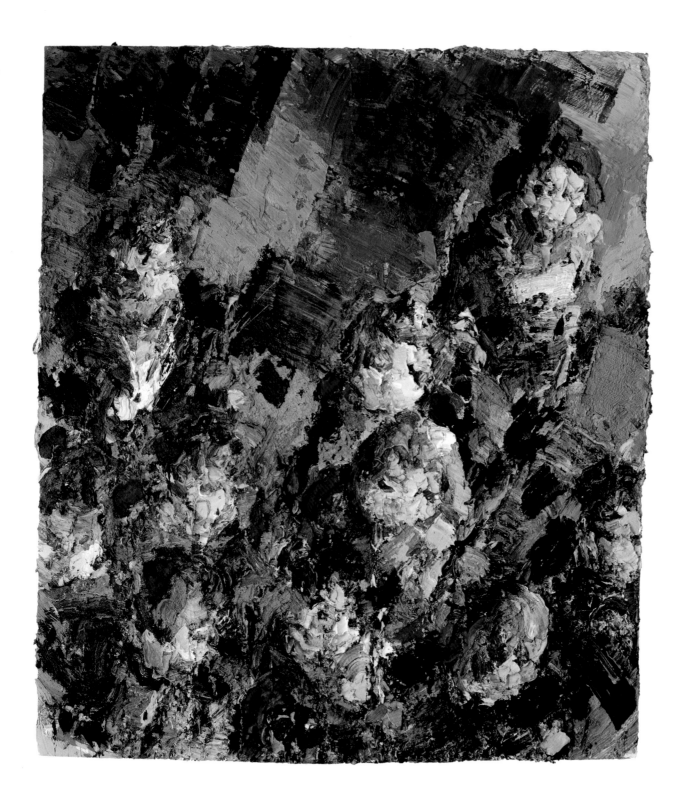

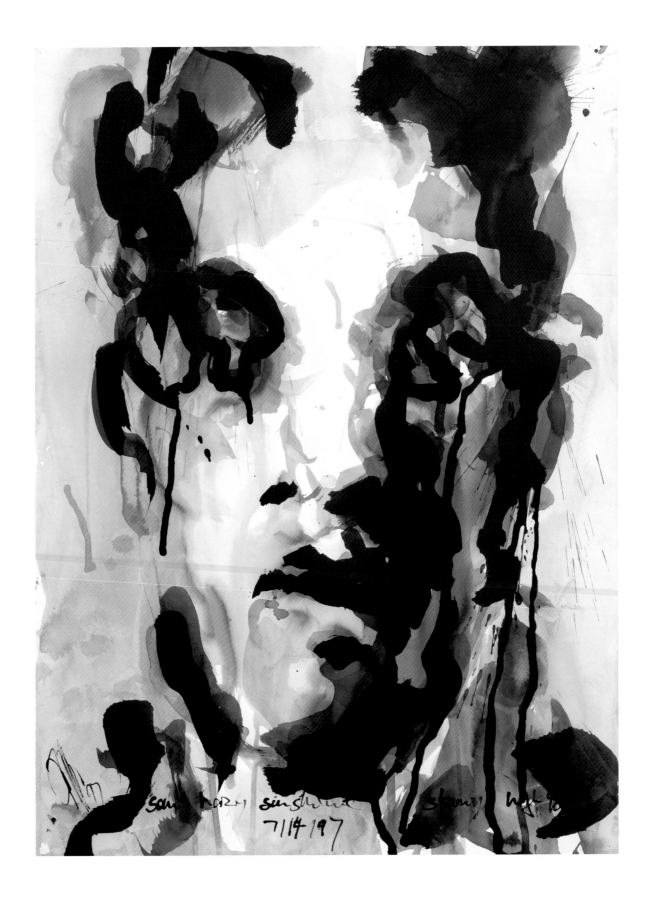

David Stern and Karen Wilkin
A Conversation

I regard my paintings as innumerably different shaped vessels whose contents vary according to the experience of the observing individual (including myself). The contents have to take on the shape of the vessel, eventually.

David Stern, 2008

KW Let's begin at the beginning. How did you know you wanted to make art?

DS I started to draw as a child, obviously. And I was interested in art until I was maybe fourteen, fifteen years old. And then I lapsed into something else completely. I came back to it, seriously, when I was about twenty years old, studied at a painting school in Dortmund, and decided to paint on a full-time basis.

KW Were you the kid in the class who could draw things that looked exactly like reality?

DS No—not really.

KW So you didn't have that kind of facility.

DS No. I acquired it the hard way, working.

KW When you studied painting, did you have a very traditional kind of training?

DS The art school I went to was a studio school. But it had also design departments. I was there for about three, four years—four years. Actually, I learned how to paint—let's say that.

KW Your paintings often seem relatively abstract, although there's always a very clear reference to something perceived that emerges if we pay enough attention. Did you ever paint completely abstract?

DS No—never. I was and am interested in the figurative. I always believed that there has to be a reference to the visual world, as we experience it. That, of course, also requires abstraction. There really is no other way to paint than to abstract from reality, real or felt.

KW And your early work was more figurative than your present work?

DS Much more. My work is and has always been figurative. I try to use the universal experience of the visual world as a point of reference.

KW You were born, raised, and went to art school in Germany. You have a following among German collectors. What made you come to New York?

DS I used to live in Cologne, for about ten years, and I needed a change of place. I needed to get out of Germany. I was born there—I lived there for thirty, whatever … thirty-six years? My wife and I looked at the various options, and I came to New York by default. My first choice was Toronto, Canada. They didn't take us, luckily, so we came to New York.

Adapted from a public conversation between David Stern and Karen Wilkin at the New York Studio School, January 16, 2007, and subsequent exchanges, verbal and written, winter and spring 2008.

Daily Drawing, 07/14/1997
Mixed media on paper
30 × 22½ inches
Artist's collection
See also p. 59.

KW Toronto first choice.

DS That was for peace of mind. And …

KW For the hockey?

DS That was a temptation. For sure they produce the best hockey players in Ontario. Seriously, I wanted to be in a place without much cultural history and ballast — coming from a two thousand year old city, Toronto seemed to be a good choice.

KW What happened when you came to New York? Did your work change?

Skypiece
1999
Oil on cotton
63 × 52 inches
Artist's collection
See also p. 49.

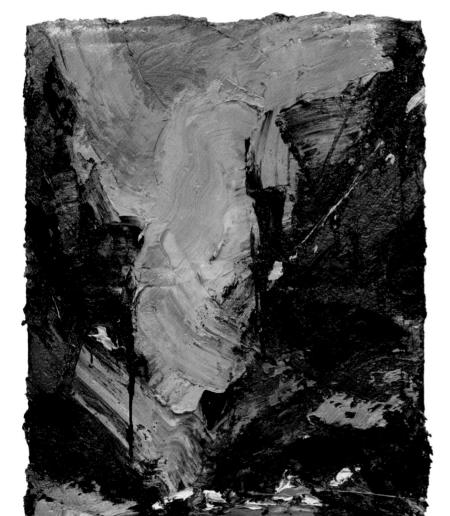

DS Not immediately. But, after a while — yes, sure. I was quite overwhelmed. I had a culture shock when I came here. And so, first of all, the figures completely disappeared from my work. I painted mostly landscapes.

KW Was this because of New York light? Or was it just avoiding the issue?

DS I was overwhelmed by the size of New York — by the sheer size and force of it — and I think I didn't see the people in the beginning. I started seeing people only after a while.

KW One of the first people you seemed to see was yourself. You embarked on a long, ongoing series of self-portrait drawings, one done every day.

DS Maybe that's the first person I recognized. Yeah. I always did self-portraits throughout my career and this seems to intensify in periods of change. I have been doing this for … seven years? Six, seven years. I used to do one a day. The rules were that I had to finish that drawing the day it was started and I could not throw anything away. So that was quite some pressure. Sometimes it would take a few minutes and sometimes it would take the whole day to do it.

KW And they're quite large.

DS They're about 30 by 22½ inches.

KW Many of them have the date and a short description of the weather that day — like a condensed weather report — written on them.

DS Yes, I used the front page New York Times snippet about the weather — quite poetic, sometimes, almost haiku-like. Sometimes I took the headlines. Usually it's something outside of myself. So it's kind of the connection with objectivity, somehow. In and out of reality.

A Conversation

KW In and out of reality certainly describes your work. I mean, you can read your portraits and self-portraits as almost abstract arrangements of strokes and tones, and you can also read them as recognizable individuals who stare back at you. The self-portrait drawings work the same way. They're about mark-making and touch, they don't look as if you scrutinized your own appearance, but they seem to be less about an *idea* of yourself and what you look like than responses to real experience.

DS I'm not looking at myself, though. I did not look in the mirror for these. It's a self-image. I believe that everyone carries a type of fixed self-image inside himself. I taught for a while in Germany, and I found that my students were always prone to draw or paint an image of themselves; especially at the beginning of their exercises, they always found themselves in the model. So my self-portraits are portraits of that inner self-image, something that is solely imaginary, if you want. Like the feel of the day inside, you know? Completely personal.

KW Did you ever paint from the motif — from nature?

DS Yes I did. The *Skypieces* — I did a series of them in the 1990s — I did sketches for them. I went out into the street, and stood in the middle of the median of Park Avenue — sketching the sights.

KW When we were talking about this earlier, you said you've become more and more of a studio painter.

DS Yeah.

KW And you're not working from sketches.

DS No, not anymore. I do sketches but I don't work directly from them. I don't work with models and I rarely go outside and sketch from reality anymore. I work almost exclusively from memory and my accumulated knowledge of the human figure, although the portrait work I've done over the years still derives from sketches made from direct observation. But most of the work is based on observations I make … walking around, living.

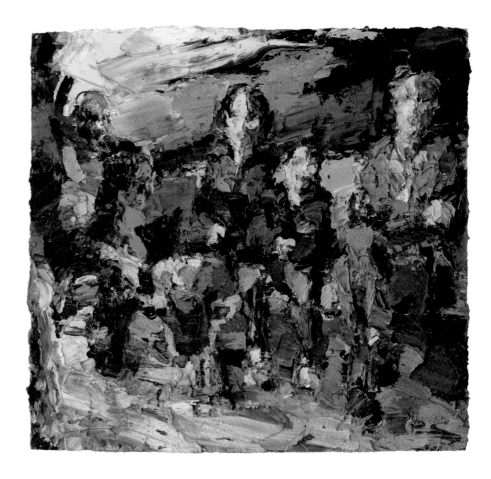

KW When did the figure come back?

DS I think it was '97 when I started allowing figures back in.

KW A lot of the earlier figure paintings seem to be about people in very specific situations. They're …

DS Confined.

KW There was a series of people sitting around tables, in what seemed to be very small spaces. There was a series about people on the subway.

DS Right. There was a series called *Common Ground*. It was a fairly large group — maybe fifteen, eighteen, twenty paintings — and they were my observations about the democratic nature of the subway. I was a little naïve back then. But they're all about confined situations.

Random Cycles — Florescent Run
1998–99
Oil on cotton
65 × 70 inches
Artist's collection
See also pp. 56–57.

Karen Wilkin and David Stern

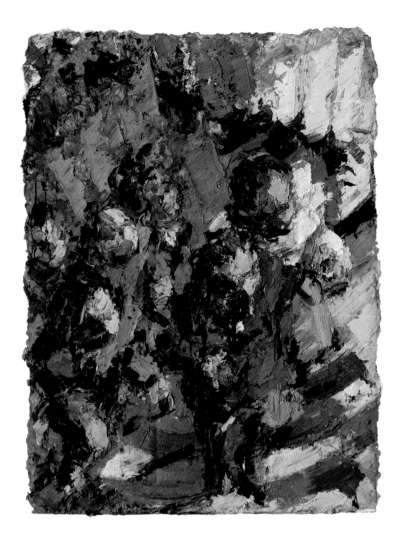

*September Skies —
To the Rafters*
2003
Oil on cotton
75 × 58 inches
Artist's collection
See also p. 97.

do that because you want to find something new, which you couldn't say in the first painting — or in the second or the third. But, after a while, it can become something like a mannerism. And I needed to change gears. So that's the reason why I moved onto the streets.

KW The thing that hasn't changed — whether the spaces are confined or whether the figures are moving through the street — is that there have been some pretty fraught images. There are post-September 11 paintings and the painting that was inspired by a friend's automobile accident. Even if you don't know anything about the specific event that generated these paintings, some of them are rather disturbing. The figures are always in what appear to be very specific situations that are slightly ominous, whether or not you can identify what those situations are.

People seem disconnected from each other, unstable. Maybe it has something to do with the way the images seem to have coalesced only for the moment and always threaten to dissolve back into patches of paint. Maybe it has something to do with your viewpoints. You rarely let us viewers know quite where we're located.

DS That's true.

KW You've said you think of yourself as a genre painter.

DS That's right. I believe that the organization of figures in space can somehow express a little bit more than just that situation itself. The figures should be in that specific situation, but it should transcend that situation, also. So I would say I'm a genre painter — absolutely. The last one.

KW Not a history painter.

DS No, no — I don't think so.

KW Even though you're dealing with large-scale figures. It's an interesting distinction. As soon as you

KW Confined — that's interesting. But your people seem to have moved out into the street lately.

DS Yeah, they have.

KW Is it that you're feeling more aggressive about America, or what? What got them out of the subway, into the street?

DS I'm not sure, exactly. You know, I expanded my horizon a little bit. Also, I got a little bit tired of repeating. I used to be a "serial painter," so to speak, and now I'm changing to more and more singular pieces. When you paint a series of paintings, you

A Conversation

have more than one figure, you've got an implied narrative.

DS I try to avoid that, though. I try to have the figures in an actual situation. I do not want to tell a story, so I try to have them doing something. And they should continue doing this — they should not stop doing this, at all.

KW Your paintings are usually fairly large and your figures are roughly life-size or bigger. The figures all-but disappear into the load of paint, so there's an implication of transience and of continuity. That action you want to suggest seems to have happened before the painting began, and will continue after you stop looking at the painting. It's implied by the way the paint's put on, in a sense.

DS It's not that I try to play some tricks here. It develops this way. I am a gestural painter, in a sense — there's a lot of action going on when I paint, so moving the masses of pigment on the canvas apparently also creates moving figures.

KW That helps to explain something I've always been very interested in, when I've seen new groups of your paintings and then returned to your studio, and watched them evolve. It can feel as though the figures are moving around on the canvas — that you're moving them into different positions as the pictures develop. They can end up in their original positions but they can also move further back in space or move to one side. Am I right in thinking that the composition's not entirely fixed, until the very end?

DS That's true. When I do a painting, I do not start with a plan. I start with some rough idea — sometimes an abstract figure composition — and then things develop. The paintings are developed through a process of action and reaction, meaning that the painting evolves without a preconceived plan or an image of a desired result. It's not the most economical way of developing a painting, but that's the

way I develop them. After I'm tossing around with them for a long enough time, they're falling into place. That's the way they should also feel. There should not be any choices left — that figure moving there, or there or there.

KW So the imagery evolves out of the paint?

DS It seems to be like that. You also have to give yourself some chances for accidental happenings. I mean, you have to see how things develop and then push them further, into a direction. The painting has to surprise you, somehow. The painting also has to generate more energy. Everything you inject there should come, somehow, back — and you have to have the intelligence to follow what the painting's trying to tell you. It's not like you have a plan and then you execute it. That's why it's kind of complicated.

KW It also seems to take a very long time.

DS Yes, it does. The painting process of a single work can take a year or more of probing, although the actual act of painting is fast and impulsive.

KW And uses a lot of paint.

DS Yes, it does, too.

KW So there's a lot of scraping off?

DS It's a violent process sometimes. It's important that the scale of the painting is limited to the span of my reach, so that the marks I make will stay as authentic moves of my hands. I use small brooms, pieces of cardboard, spatulas, brushes, too.

KW You use brushes, too?

DS Brushes, too.

KW It's nice to know that there's still some traditional paint application going on. I've always been struck

Karen Wilkin and David Stern

by the sheer amount of paint that you take off the pictures. It's remarkable that there's still so much left on the canvas when you're finished.

DS When I moved from my last studio in Soho to Chelsea, we had to chip the paint from the floor. We had to chip out big pieces and I had to saw it into little pieces — you know, to be able to carry it out. It was quite something.

KW That's dramatic. I didn't realize that you had to have physical interventions to get out of there.

DS It was tough. Chunks about twenty by thirty by ten inches — they were heavy. They were thirty, forty pounds.

KW It can't be recycled?

DS We had a guy to discard it. I don't know what he did with it — I have no idea.

KW You say you want the figures to have a sense of hav- ing reached their point of equilibrium. But there's always implied motion in the paintings — the figures always seem off-balance in some way.

DS You know, it's a contradiction. They have to work as figures. I mean, they have to give you the impression that they are full, complete figures, with all their fin- gers at the right places. But, at the same time, they should move in and out of reality. They should also move quite figuratively.

KW That combination of specificity and abstractness is certainly one of the striking things about your work. It's like seeing something out of the corner of your eye. The image seems very complete and yet you haven't focused on it in a particular way. In a sense, your paintings are very truthful to our perceptions — and to your own perceptions, of course. The longer you're in New York, it seems, the more New York light seems to be getting into the pictures, which is, I suppose, inevitable. But it's noticeably different now than it was in your first New York works. I remember coming to the Greene Street studio after

several earlier visits and suddenly being confronted with figures walking through streets with patches of unmistakable New York winter sky visible between them. And it was completely new.

DS I came from far North. I came from Germany, which is around the same height on the globe as Hudson Bay. There is not much light up there. New York was certainly a revelation lightwise, definitely.

KW New York is on a line with Rome. Matisse was so excited about New York light, when he was on his way to Tahiti, that he considered not going on any further. But I want to get back to your approach to the figure. I know you do a certain number of com- missioned portraits. How does that fit in with your practice?

DS It fits in pretty well. I do commissioned portraits, but I do portraits no matter what — commissioned or not — because I somehow need to be grounded a little bit. I need to have a reality check once in a while and so I have always done portraits, through- out my entire life as a painter. It's a challenge, you know. It has to work as the figure you want to por- tray — and you want to recognize the person, some- how, as well. And, at the same time, the painting has also to bring the whole drama of human exis- tence into place.

KW How do you work on the portraits? Do people sit for you?

DS They sit just for the drawing part. I do the paintings by recollection. I have the drawings pinned up on my wall, and I try to remember what I was con- fronted with.

KW I must say, I found sitting for you a rather terrifying process. I wasn't expecting a likeness, but I wasn't expecting to see images of my grandmother, either. It was sort of like a foretaste of the future. The paint- ing was terrific, as a painting. But it is disconcerting sitting for you.

DS That's good — I like that.

Karen
1999
Oil on cotton
28 × 16 inches
Private collection

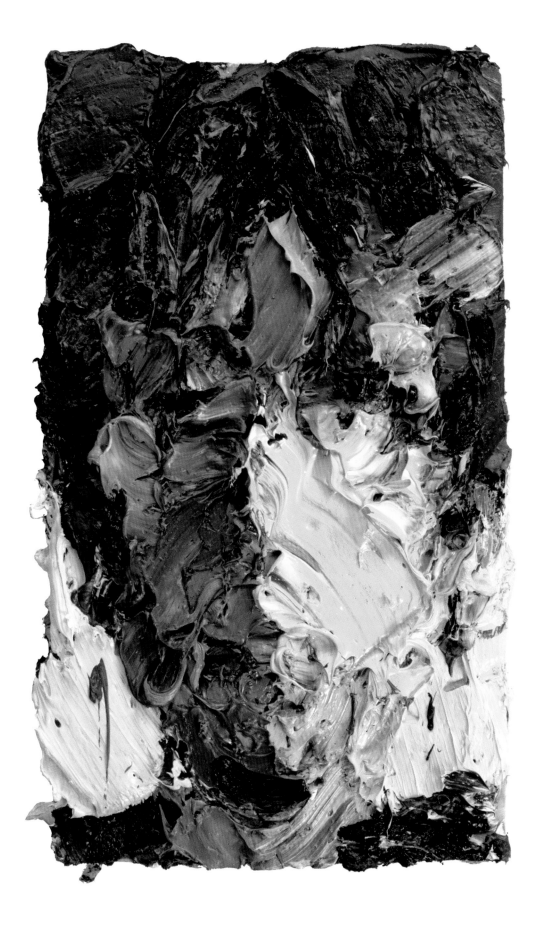

KW Your principal concern is always the figure. You once said you thought that it was the most significant thing you could paint. But I have a question about you using figure — a question that comes out of ignorance. You are a painter of the figure and you are also an observant and practicing Jew. We always hear that Judaism is an iconoclastic religion — apart from what we learn in art history surveys about the frescos on that 3rd century synagogue from Dura Europos and a few surviving medieval manuscripts.

DS Right.

KW So how do using the figure, observance, and iconoclasm fit together?

Scotch and Orange 4
2002
Oil on cotton
42 × 36 inches
Private collection

DS First of all, I think it's a misunderstanding. It's been said that you should not make graven images — which means that you should not make

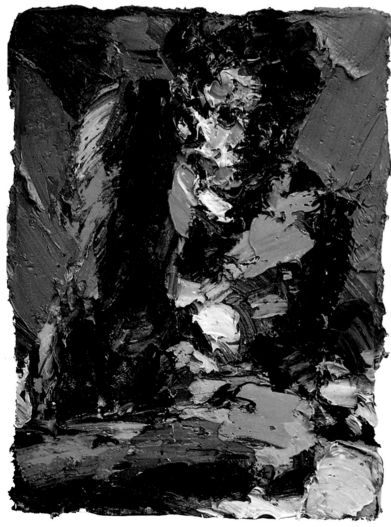

idols. And much as I might want them to, nobody prays to my paintings. That's not what I try to achieve. Though you could say, if you tried to make them alive, there's a little bit of a contradiction there, as well. But in a literal sense, our religion does not forbid us to make images of man. Images of God are different. But images of man, I don't think are a problem.

KW So, in a sense, the painter is in the position of God, in this case.

DS Yeah. Let's not get further into this.

KW You could say that your emphasis on the materiality is a means of getting away from this problem, because it's always very clear that your figures are made of paint. This is not an imitation human being.

DS That's certainly one thing I don't want to do. As much as I don't want to have a narrative, I also don't want to have this kind of photographic feeling — you know, like imitating reality in some way.

KW Nothing photographic about your work — nothing that feels like imitating reality.

One fairly recent series, which I remember as being very, very powerful, seemed to me a bit unusual, in that the viewpoint changed. In many of your works, it feels that we're looking up at the figures. But in the series I'm thinking of, the viewer is looking down on the image. I know there have been a few others in the same vein — there was a circle of crouching figures in the post-9-11 paintings …

DS There are four paintings, called *Scotch and Orange*. They were about personal feelings after 9-11. I've been somehow experimenting with perspectives for quite some time now.

KW Until recently, the viewpoint was quite consistent. We had the feeling that the figures were walking towards us or that we were at a lower vantage point and looking up at them. Now, we can feel as if we're

levitating, confronting some inexplicable event. Was the change conscious, or did it just happen?

DS It just happened. But it can vary from painting to painting. In the post-9-11 paintings, in some of them you look down—in some of them you look up, too. Or look straight into them.

KW That sense of confrontation seems to be very important, though.

DS Yeah. As I said, these were about a theme. It was more like an introspective thing, about how one feels after 9-11. So that was done pretty much right after that—in 2002.

KW Do you think of yourself as an expressionist?

DS Not really.

KW You can't be a genre painter and an expressionist?

DS No, I don't think I'm an expressionist. No, not really. Maybe an action painter—I'm more like an action painter. Genre and action.

KW Okay—we've got a new category. When we look at your paintings, we almost recapitulate, mentally, the experience of all that stuff being put on the canvas. The paint's extremely juicy and there's a real sense of physicality—which, somehow, equates with a sense of heightened emotion, or, certainly, heightened intensity.

DS After all, I come from Germany, so it's kind of—you know, what can I do? I grew up with expressionism.

KW Didn't you leave Germany about the time that the Neue Wilden were coming into prominence?

DS Actually, a little bit later than that. But pretty much, I lived with them in Cologne.

KW I always felt that the Neue Wilden were very consciously basing their work on German expressionism and somehow fusing it with American Abstract Expressionism, in some very peculiar way.

DS I always thought that it was not really serious. They were taken seriously by the art world, but I don't think they took themselves that seriously. They were presented as the legitimate successors of the likes of Max Beckmann.

KW There was an appalling show in London in the 1980s that billed itself as an overview of modern German painting but seemed designed solely to create a lineage for a chosen few stars like Baselitz and Beuys.

DS Yes, right. I remember that as well.

KW That show was full of exclusions and omissions, but the best thing about it was a great, great selection of German expressionist paintings. It had a lot of wonderful Beckmanns; there was a room full of Christian Rolfs. The only problem was that they were all treated as a preamble for all the recent people for whom they were trying to create a legitimate line. But the first part of the show was very good.

What are you working on now?

DS I'm working on four large figure paintings, each one situational.

KW And is the situation specific or is it ambiguous?

DS I would say it's specific—but you would probably call it ambiguous, as well.

KW Can you tell me what the specific, ambiguous situation is?

DS No, I can't. That's why I'm a painter. I'm not a storyteller.

Karen Wilkin and David Stern

Dancing in the Dark
2007–08
Oil on cotton
58 × 75 inches
Artist's collection

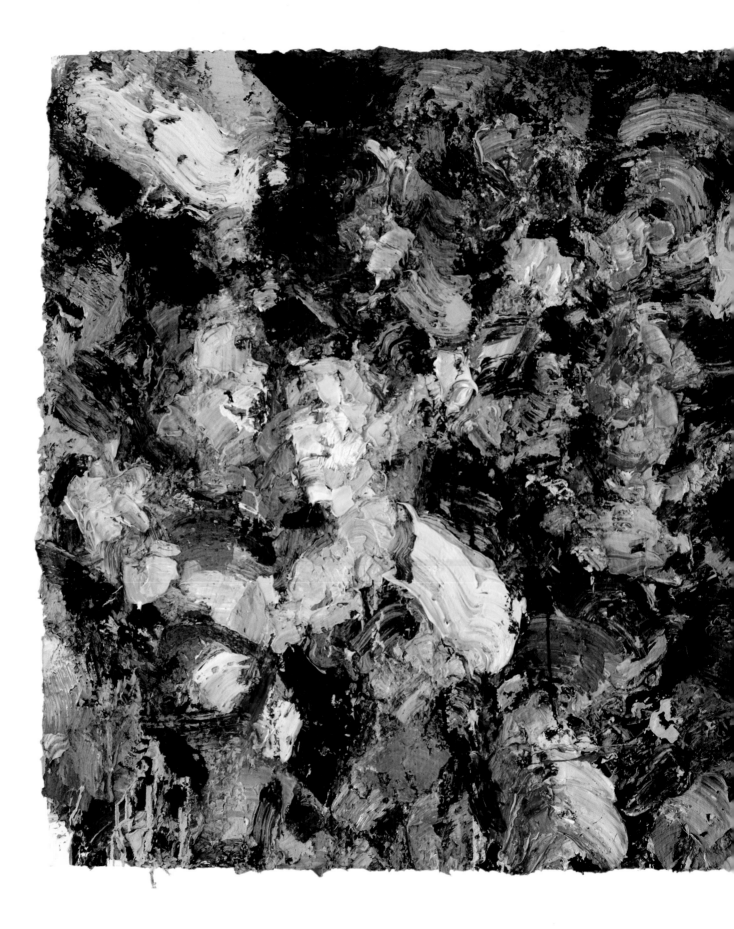

Excess and Restraint
The Paintings and Drawings of David Stern
Lance Esplund

A PHOTOGRAPH OF DAVID STERN in his SoHo studio accompanied a 2002 *ARTnews* profile. In it, Stern, clad in black, paint-encrusted coveralls, and with a thick head of slate-gray hair, is handsome and imposing. A workman-painter, he has the air of a steelworker — of a man ready to build big things and to move heavy objects. Stern does not appear to be posing. Standing alone, engaged with his work, he looks as if he had just been interrupted at his easel. He stares out at us from a corner between a heavily impastoed, oversized portrait head and a canvas depicting a nearly life-size group of figures, an unfinished painting from *The Gathering* series. Holding the tools of his trade — a large trowel or spatula in one hand and, perhaps, a brush in the other — Stern is brooding and serious. A self-proclaimed "action painter," he looks as if he could hold his own in the company of David Smith, de Kooning, Pollock, and Kline. He has the cocked-hip swagger of a Wild-West gunfighter; and his battered studio, whose floor and easels are caked thick with paint, and whose canvas-covered walls from floor-to-ceiling are spattered with pigments, evokes the aftermath of a bloody battle and gives Stern the heroic presence of a last-man-standing.

The *ARTnews* profile, written by Blake Eskin, is titled "A Passion for Impasto." This is characteristic of articles written about Stern (one of my own reviews, titled by an overzealous editor, was called "Working the Paint"). But these titles, as well as the photograph I discussed above — a photograph which in fact is a candid and

Lance Esplund is the chief art critic for The New York Sun.

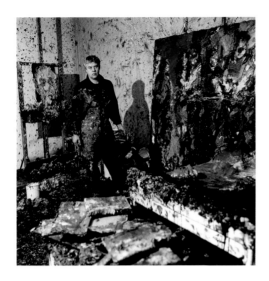

David Stern in his studio,
2002
Photo © Eric Feinblatt

accurate portrayal of Stern's working process — paint a somewhat false portrait of the artist; or at least they foster an image antithetical ultimately to what Stern's work is about. Shifting the emphasis from what Stern's pictures do and are to how they were made and to what they look like, they put process over substance; they put the life and movements of the artist above the life and movement of his art.

This approach to art and artists goes at least as far back as van Gogh, who is seen as the epitome of the tortured artist-genius — someone whose high anxiety is supposedly self-evident in each high-keyed color stroke. And it continues to be fostered by the lineage of the German Expressionists and Neo-Expressionists — whose excess of feeling can be weighed, stroke-by-stroke, against the weight of the paint and its emotive intensity. On this side of the Atlantic, this approach to making art was cultivated and distilled or, more correctly, reduced, at mid-century by the Abstract Expressionists and their followers, who — in shifting the emphasis from what an artist's mark actually does, to the subjective and emotive authenticity supposedly expressed by that mark, and to the "gesture" or the signature of the artist's hand — began to empty out of painting, and especially abstraction, the structural and metaphoric complexity that are what makes art worth engaging with in the first place, and especially worth engaging with over time.

When discussing the work of David Stern, and, indeed, when confronted by his paintings, particularly for the first time, the most prevalent and overarching issue is the imposing thickness of the paint — as well as the startling dislocation, the sudden sense of being off-balance, that his sculptural surfaces provoke. Stern is indulgent with paint. I know of no other artist working with paint on canvas whose pictures are more heavily loaded. His turbulent, relief-like surfaces, which are inches thick, chop and roil between frosted peak and intimate crevice. Whipping tongues of paint, slick and gritty, lap around his canvases' edges, as if the rectangles, like volcanic mouths, cannot contain them.

Certainly Stern's paint — the sheer ever-presence of its materiality — must be reckoned with. And since that thickness is such a ubiquitous point of reference in Stern's work, it needs to be acknowledged — addressed for what it is and for what it isn't — early- and head-on. It is only through their acknowledgement that we can move beyond the miring quicksand of surfaces to the deeper heart of Stern's paintings. It is only then, when we have stopped fixating on the look and initial impact of his work that we can arrive, more slowly, more gingerly, at its inherent tenderness and vitality.

The physical presence of Stern's paintings is always demanding. For some, the surface may present too many obstacles; it may demand too much effort to traverse and ride, in order to arrive at what is perceived to be the prize — the images embedded in the paint. But the experience of any painting, no matter how thick or thin, is that of how your eyes move — from form to form to form — over and through the painted surface. It is not important how much or how little paint an artist employs; it is only important that he convince us, as Stern does, of its necessity.

Every artist has a hand — a temperament: "I paint this way because I must," declared the French painter André Masson. Stern, who was born in Essen, Germany in 1956, and who lived in Cologne from 1980 to 1995, is a northern painter by birth and disposition. Just as southerners speak differently than northerners, painters cultivated in the south traditionally make different paintings than those in the north. Certainly, the art of Stern's German Expressionist forefathers and Neo-Expressionist contemporaries had an impact on his work (Expressionism was in the air), just as the northern light, landscape, and harsh winters had their effect on the artist. And painters who move in either direction, or who move from the country to the city, usually respond in their art to the change of light and scenery (Stern immigrated to New York City in 1995, and

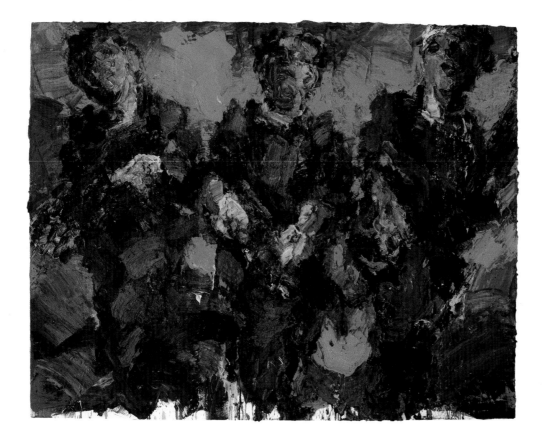

Coming Home
(sacra conversazione)
2007
Oil on cotton
58 × 75 inches
Artist's collection
See also pp. 140–41.

of burning embers. The men, who might be dancing on fire, are latter-day saints; but they could be devils, shamans, or heroes; and this paradoxical scene suggests that their acts have multiple consequences.

In passages, the bright red ground pierces their bodies, glows in their eyes, and advances in front of the figures like a wall of flame. Stern's color, malleable here, stands in for more than one thing: red is light and life; energy, ground, blood, and fire.

Here, as in almost all of Stern's paintings, the world inside the figure cannot be separated from the figure inside the world. Rectangle and man become inseparable, synonymous. In *Coming Home*, as in most of Stern's paintings, forms emerge from out of paint into figure and back again, as if the artist, dipping his hand into a primeval yet luminous mud, was forming man right before our eyes.

And there is something captivating, raw, and sensuous — something in the way a Stern figure vacillates between flat and thick; between course and slick; something in the way the figures rise and fall and turn within the paint; in the way that, though frontal, their heads appear to shift from frontal to profile to three-quarter views — and especially in the way that we are right there in the deep mess of it all, feeling the stirring search of the artist's hand — that moves Stern's paintings beyond the easy metaphors of erotic urgency, Dionysian excess, or existential struggle, to arrive at something that, far from anxious, destructive, exaggerated, or extreme, is actually quite tender and life-affirming. When Stern is at his easel he is not indulging in a "passion for impasto"; he is a workman-painter, raking the coals and stirring the cauldron — celebrating the act of creation.

Lance Esplund

Cold Cuts
2007
Oil on cotton
58 × 75 inches
Artist's collection
See also pp. 156–57.

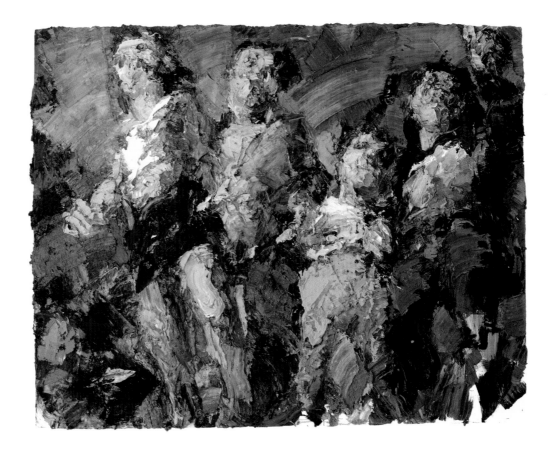

But I believe that it is in the most recent pictures, in which Stern has abandoned working in series and prolonged narratives; instead, tackling each painting with a singular sense of do-or-die purpose—as if each work were a dramatic portrait of a remarkable event—that he has most beautifully combined figure and environment. In these recent pictures of couples and crowds, in which we are often looking either down or up at figures huddled together, their heads sometimes resembling bunches of large ripe fruit on a tree, Stern creates a spinning vortex in which up and down are seemingly interchangeable.

In *Cold Cuts* (2007), Stern creates a topsy-turvy world wobbling above us. Five squat figures, their heads and limbs as thick as sausages, tower and teeter over us, yet they also appear to be swept along and roll back into space. Both frightening and childlike, the figures look as if they could be jumping joyously or ready to stomp us. In the large *Coming Home (Sacra Conversazione)* (2007, p. 37), three beleaguered characters, as if out of a Brothers Grimm's fairytale (far from the traditional Madonna, Christ Child, or saints usually associated with the theme), move toward us. Threatening to burst from out of the canvas, and looking down on us, they bob to the rectangle's edges. And yet, with their childlike, corkscrewed faces, and arms held together as if bound or, perhaps, in prayer, the figures (although they relate to the last war Israel had to fight against Hamas in 2006), and their intentions remain perpetually ambiguous.

Stern has turned up the heat in this painting. As in his work on paper *Above and Below* (2006, pp. 136–137), its red-hot oranges and ashen-coal blacks give the canvas the light of a low, strong flame and the submerged heat

Excess and Restraint: The Paintings and Drawings of David Stern

streets, and sky. New York, with a unique energy and ebb-and-flow of its own, had a deep impact on the artist. Stern's palette changed to New York's palette—to the cool biting blacks and whites and silvery grays of the streets and architecture; to New York's rich golden, southern light; and to the magnificent range—from purple to turquoise to cobalt to cerulean—of New York's sky. The orientation of his pictures also shifted from horizontal (or landscape) to vertical (or portrait). Stern, a figure painter at heart, began to make portraits of the city. He painted the movements of the sky, as well as the strong triangular wedges of gray buildings, rising upward; and of the triangular wedges of sky-blue, pressing down to the streets.

In some of the New York *Skypieces* (1999–2001, see pp. 42–49, 72, 86–87), the sky thrusts itself down into the vertical rectangle, as if the wedge of sky were one of Stern's single conical, full-length figures—figures whose arms feel bound to their sides; and who, like lawn darts, appear to have been shot down into the base of the canvas; or, like plants, to have sprouted up from out of the soil. In New York, the upward thrust of the architecture is countered only by the downward thrust of the sky, which, as you look down an avenue, is compressed between the buildings, as it pushes to the street. These two opposing forces simultaneously lift you skyward and drive you into the pavement. And it is precisely this experience that Stern achieves in his paintings, or portraits, of the city's streets. What saves these pictures from being oppressive is their sense of push-and-pull, of their being grounded and of taking flight; as well as their beautiful and believable New York light.

Stern tackles equally vital and visceral experiences of New York in other series. He explores Gotham, in the streets and in the subway, as a complex organism. The *Random Cycles* pictures (1997–2000) shift our attention from the verticality of skyscrapers to that of people, and to their forward momentum. We experience the edge-to-edge expanding pressure of the city and of the single-mindedness and mob-mentality of the rush-hour commute. Figures are pressed side-to-side like sardines; yet they have a driving frontal presence that allows us to experience them both as individuals and as interlinked

and interwoven masses. Men in suits and long-legged women in short skirts each have a particular gait, stride, rhythm, and personality: together they comprise a harmonic rush of color and mass. And there is humor in Stern's observations, as in *Random Cycles—Short Shots* (1998, p. 63), in which a child is being dragged along and pulled upward, as he is also seemingly being carried by the energy and flow of the sidewalk. In the beautiful gray-violet *Random Cycles—First Takes* (1997), we experience a near-collision of characters—people who appear to be fractured into and carried by a rapid flow of color and energy.

In the *Common Ground* series (1996–2000, see pp. 56–57, 76–79), Stern's subject is the subway. Figures are tightly packed and sandwiched, or crumbled like wadded paper; and, as in New York's subways, larger pockets of space suddenly open up, giving the scenes the upended tilt of an unevenly weighted scale. Stern is placing these figures on a moving train; yet the experience of the paintings is that not of figures trapped in a racing object, but of energies rushing through the figures, each of which retains a near-portrait level of specificity and personality.

After the events of 9/11, Stern embarked on a series he called *The Gatherings* (pp. 92–95), in which he grouped figures together in common purpose, not just on common ground. The paintings, which were inspired by scenes of New Yorkers gathered and clustered together around flowers and during candlelight vigils, create communion and elegiac ritual out of informal mourning and remembrance. Stern has also created paintings about the birth of one of his children in *Woman in Labor* (2001, pp. 90–91), as well as, in *A Tribute to Gus and and Harry* (2003, p. 107), the aftermath of (and arduous recovery from) a car accident he witnessed that involved a close friend. Some of these scenes, though often large, have the intimacy of Frans Hals.

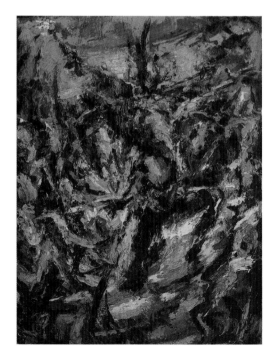

Studies for an Orgy I
1990
Oil on cotton
90½ × 71 inches
HGB Germany

Lance Esplund

as the world vivisected and laid bare. In the landscape series *Triptyca: Three Studies for a Way* (1987), rustling trees, pathways, branches, and sky all assert themselves with the intensity of lightning. Yet we feel a leafy, deep-forest light in the paintings. In *Winter Landscape with Sequoias* (1988, p. 34), the trees form a façade that is both architectural and human, and the funneling sky pours and presses down to the earth, as it also appears to shoot upward like a geyser.

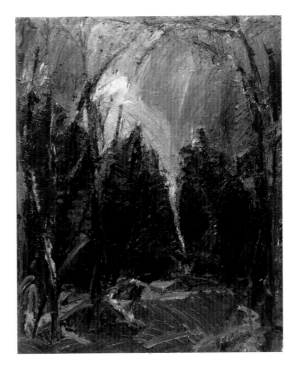

Some of Stern's paintings from the early 1990s, including a number of works made in series, feel like portraits, not of people but of elements, energies, and actions—as in *About the River* (1992–93), a beautiful series that explores the colors of water, earth, cloud, and sky, as well as the texture of mud and the movements of the river; or the *Orgy* series (1990–1992), in which Stern gives form to sexual actions and energies—lust, passion, heat, and frenzy. In these earlier paintings, it is as if Stern, though not painting abstractly (although it is impossible at times to discern what, exactly, you are looking at), is thinking as an abstractionist—an artist/scientist/alchemist—who is studying, collecting, and distilling universal relationships in paint on canvas. And since many of these pictures are quite large—as in the fiery tumult, the nearly eight-by-six-foot painting, *Four Studies for an Orgy I* (1990, p. 35)—their experience is that of being immersed at the center of the storm.

What convinces us in Stern's explorations is that his forms feel genuine and appear to have evolved, and to be evolving, within the fluid surface of the canvas.

This is also true of Stern's lush, calligraphic drawings, many of which he completes quickly, finishing in a single sitting or, as with the years-long series of daily

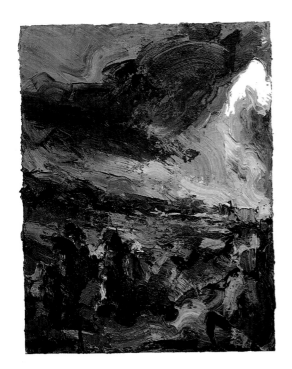

self-portraits, each in a single day. In the drawings, we experience Stern's graceful searching hand—its restlessness, lightness, and fluidity. Our eyes do not follow Stern's drawn contours; so much as they are rocked and caressed by them. In Stern's quickly moving figure drawings (he generally makes numerous studies of a subject before he begins a painting), contour lines dart in and out and rarely close. The figures feel as if they are in motion. It seems only natural, then, that in Stern's figure paintings—in which the studies inform the creation of the figure—the thicker and more swirling the paintings become, the freer within the canvas become the figures.

•

IF STERN, LIKE A SCIENTIST, was collecting elemental energies while working from the landscape in Germany, it is in the most recent work, completed in the last twelve years in New York (the drawings and paintings represented in this exhibition), that Stern appears to be melding the energies of the figure with those of the environment.

When Stern first arrived in New York, in 1995, he painted the city. As if to get his bearings, Stern stood on the sidewalks and made drawings of the buildings,

protective of each other, they had carved out a special pocket of their own. They are rooted to the frame of the painting, yet—one twiddling his thumbs; the other seemingly melting—they each retain an exacting individual presence.

Violence and compassion go hand-in-hand in Stern's pictures. Often he gives us a view of looking up or down on a group of figures, as in *Strings* (2005); and, although he presents a narrative, ultimately we must work out our own stories in the paintings. In *Strings*, we witness an angry mob, or mass burial, or group of puppets, with arms outstretched, who appear to be running, hanging, drowning, or falling. Amid a sea of blacks and bruised violets, slashing reds and creams tear through, yet also provide hope to, the scene. It is not clear if the group is in need or, like a tidal wave, about to roll us asunder.

In *Gravediggers* (2007), the figures actually feel submerged within the paint, which is earthen. Here, as in other paintings, the figures' eyes, although they read as eyes, look disconcertingly as if they had been pecked clean from their sockets. At the center of the composition is a crouching female figure. She holds the shovel, and she and her attendants are looking down at us—into the grave. Her lips, a vibrant peachy red, appear to drip with blood or tendon. Amid the morbidity, however, her face, encircled by petal-like patches of hand, knee, and foliage, reads as the center of a big open flower.

And sometimes Stern gives us narratives even when we least expect them. In the artist's self-portrait *Hallel* (1995, p. 14), splatters and trajectories of flung paint shoot outward from the center of the canvas; and also, as if suddenly reversed, they appear to be directed, like arrows, inward. It is not clear if the artist is coming or going; if he sees himself as god or martyr. Here, as elsewhere in Stern's figures, the body—big-bang creation or last-hurrah supernova—explodes.

·

FOR DECADES, Stern has consistently worked at conveying authentic energies in his drawings and paintings. His landscapes from the late 1980s have an Impressionist intensity and immediacy, as if the artist were attempting hurriedly to get everything down on canvas

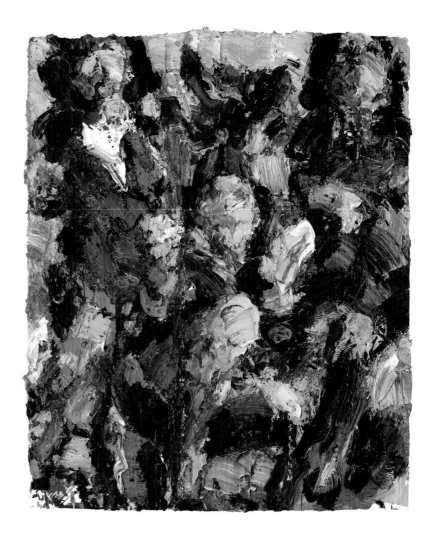

Gravediggers
2007
Oil on cotton
61 × 51 inches
Artist's collection
See also p. 147.

before the light changed. This is despite the fact that Stern paints almost exclusively not *en plein air* but in the studio, either from drawings of his subjects or from memory, or from a combination of both. Stern's landscape and cityscape palettes are naturalistic. But what is surprising is that Stern achieves in these works, as in his figure paintings, such variety, individuality, and natural light without working directly from the motif. The paintings, above all else, exude a sense of immediacy and of engagement and response—of give-and-take between artist and subject.

What clearly excite Stern as a painter are not things but the energies felt by those things—whether figures or trees or wind or light; and it is important, if not essential, for Stern to achieve and to convey life's intensity on canvas. As in Soutine, Stern's distortions feel not like exaggerations of the world but, rather,

Lance Esplund

32

Edvard Munch's iconic image *The Scream* (1893), the first painting with the sudden impact of the modern poster—is that a Stern painting or drawing is a very slow read. In Stern's paintings, forms constantly shift in depth, as well as from side to side, as if the painting is breathing; and his restless forms take a long time to settle (they never quite lock themselves) into place.

As in the elisions of Cézanne or Giacometti, the act of identifying spatial location in a Stern canvas, in which the center seemingly will not hold, is an ongoing struggle. This has as much to do with the thickness of Stern's paint, as it does with the feeling that his forms are shifting off of their axes; shifting in their skins; and even, as if they had been flayed, of turning themselves inside out. Sometimes in a Stern it is difficult to know when and where, exactly—especially along a figure's twisting, sometimes braided contours—the figure ends and its environment begins.

Despite the paintings' overwhelming heft, Stern's forms, especially the figures, can feel ribbonlike, as if they are unraveling or unfurling. This has a lot to do with the linear quality of Stern's drawing in the paint;

with how he pulls form—from line into volume and back into line—like taffy. Because of his process, Stern's figures can have a ghoulish or battered quality—a quality that, in taking nothing away from their ability to read as human, makes them feel vulnerable.

It is as if Stern's figures had endured horrible things in order to arrive on the canvas; as if they had been put through a wringer or forced to run the gauntlet; as if they had been whipped into shape. Stern's figures appear to have to fight for the very makeup and autonomy of their bodies. Sometimes they appear literally to be hanging by a thread of paint. This is more pronounced in Stern's figure paintings, in which we can actually engage and empathize with a human face, than in his landscapes; and it is the struggle—between energy and mass; between space and form; between gravity and flight—that is the fire that keeps his forms burning. Stern's figures, whose creation owes as much to the process of undoing as to that of doing, feel as if they have been hammered, wedged, pinched, stretched, and woven into being. Their very creation has required visible acts of disruption and violence, of distortion, merging, fracturing, and dislocation. Despite all of this, however, they manage to remain whole and human.

The existential tension in Stern's figure paintings is felt especially in his portraits and self-portraits, in which we can feel the battle and tenuous balance between the personality of the painting (or painter) and that of the sitter—an at-odds tug-of-war in Stern's work that heightens the intensity and intimacy between painter and model. In *Marvin and Frank* (2001–02, p. 31), a tender portrayal of a couple, the major thrust of the composition is from the edges inward, against the two figures' heads. Like all of Stern's forms, and especially his figures, the men are felt as concentrations of energies in contest with the energies of the world. The two men are pressured into place by swaths of paint. Yet the impact of the paint on the two men is not an overarching metaphoric conceit about the difficulties of life; instead, Stern's handling and forming reveal the relationship between the sitters, as well as their respective relationships to the world. The men sink toward the center of the canvas, as if, protected and

Strings
2005
Oil on cotton
71 × 81 inches
Artist's collection
See also pp. 126–27.

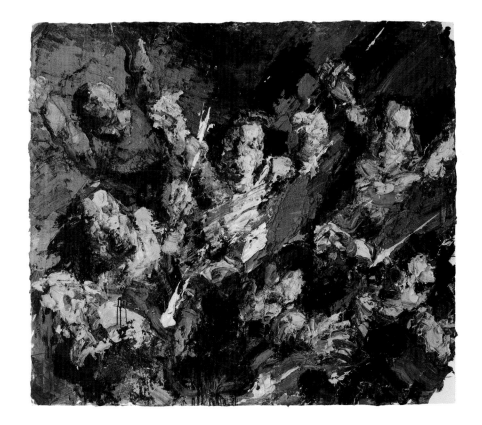

Excess and Restraint: The Paintings and Drawings of David Stern

since then his art has changed considerably). Northern painting is in his blood. But this does not make him a German Expressionist. Stern has refuted the claim that his work is "Expressionistic." Nor is he an abstractionist. He has described himself, in the tradition of a portraitist and a 17th-century Dutch painter of interiors, as "a figurative artist"—"a genre painter."

I would propose that Stern does not have "a passion for impasto" or for "working the paint," but, rather, a passion for paint and for the language of painting—a passion for doing everything it takes to achieve in his work a believable and living human presence. Stern's aim, I believe, is not to drown the viewer in masses of paint; to wow us with how much he can load onto and juggle within the canvas. He is not equating depth of feeling with depth of paint. Stern's paintings' flux and mass are byproducts, not end products, of his aims as an artist—artistic aims that demand first and foremost that his paintings achieve what he has referred to as "full, complete figures," figures that "bring the whole drama of human existence … into place."

.

THE FIRST TIME I saw David Stern's paintings was in a catalogue from the 1992 retrospective of Stern's work, which was held at the National Gallery of Hungary in Budapest. That exhibition was a comprehensive look at Stern's paintings and drawings made in Germany, just as the current show, *David Stern: The American Years (1995-2008)*, examines the work he has made since he moved to the United States.

Stern's paintings, I could tell then even in reproduction, were thick, dense, and churning. Some, as if mixed with sand, shone with a coarse light. Others were beaten into a surface that resembled whipped cream. Many of those earlier paintings are not as thick as the current work (because of this, their forms may shift into place faster than in the most recent canvases); but what was clear in the reproductions was that Stern's paintings were open and airy— spatial. They had both sculptural mass and natural light; and just as my eyes could skip easily across their planar

surfaces, like stones across a pond; or ride their waves— I could also move freely *through* them. Despite the paintings' molten density and tumultuous distortions; despite that their surfaces appeared to be thrashed and thrashing, they exuded an overriding natural-ism—a paradoxical experience confirmed when, six years later, I saw the paintings face to face.

One of the things that separates Stern's pictures from those of the Expressionists—such as, for example,

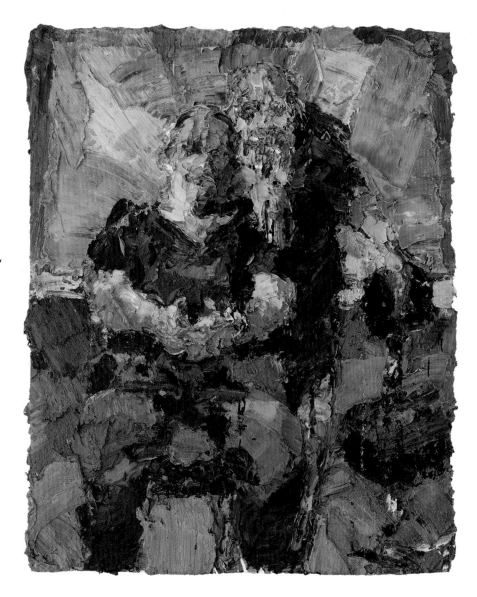

Marvin and Frank
2001–02
Oil on cotton
61 × 49 inches
Artist's collection
See also p. 111.

Lance Esplund

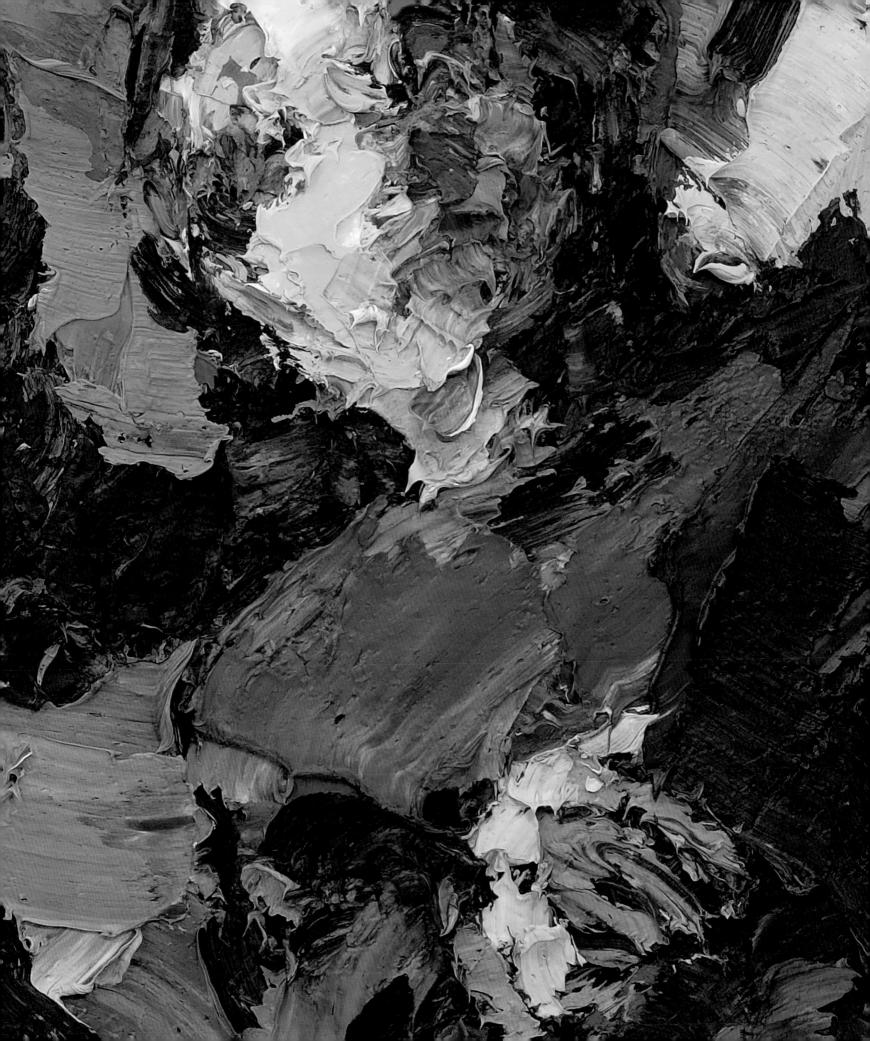

OVERLEAF
September Skies (detail)
2003–04
Oil on cotton
56 × 47 inches
Segall collection
See also p. 117.

RIGHT

Embrace (triptych, left)
1995
Oil on cotton
76 × 39 inches
Private collection, New York

Embrace (triptych, center)
1995
Oil on cotton
79 × 42 inches
Private collection, Munich

Embrace (triptych, right)
1995
Oil on cotton
76 × 39 inches
Private collection, New York

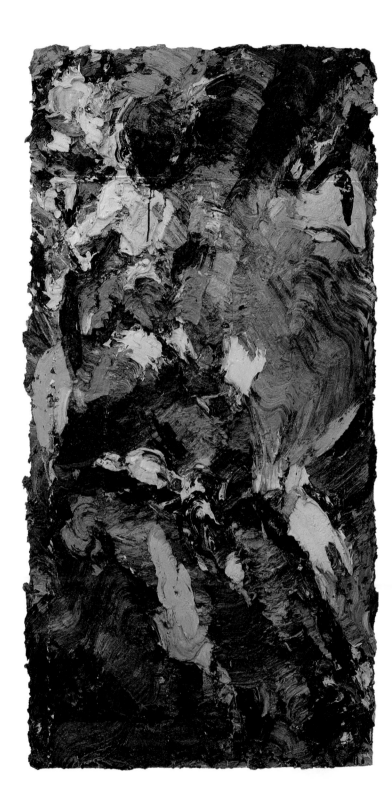

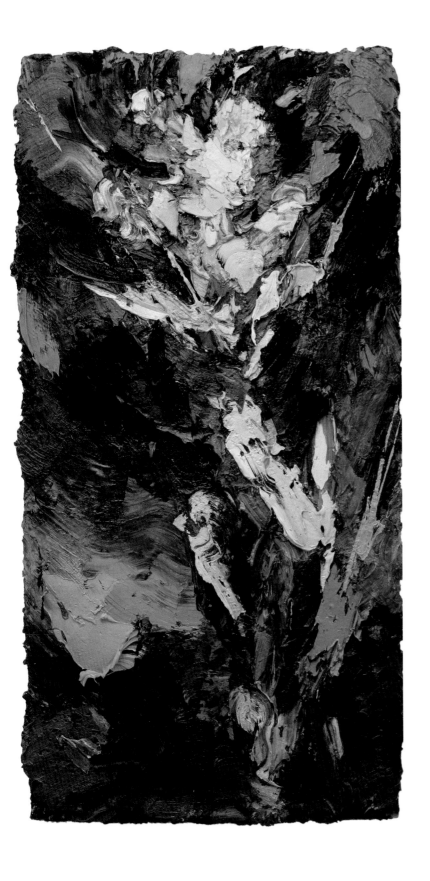
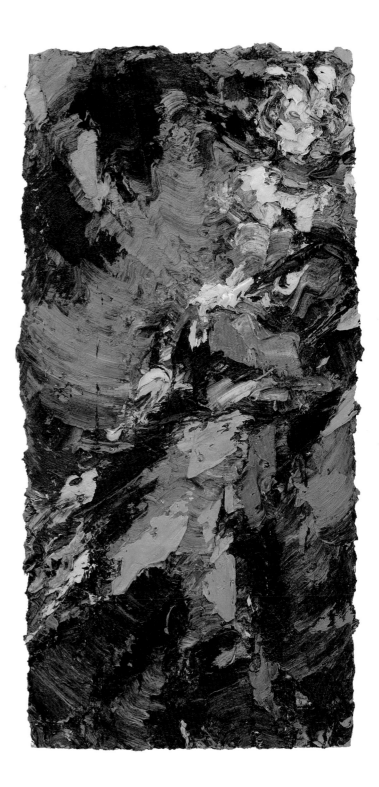

Skypiece
1996
Oil on cotton
55 × 47 inches
Artist's collection

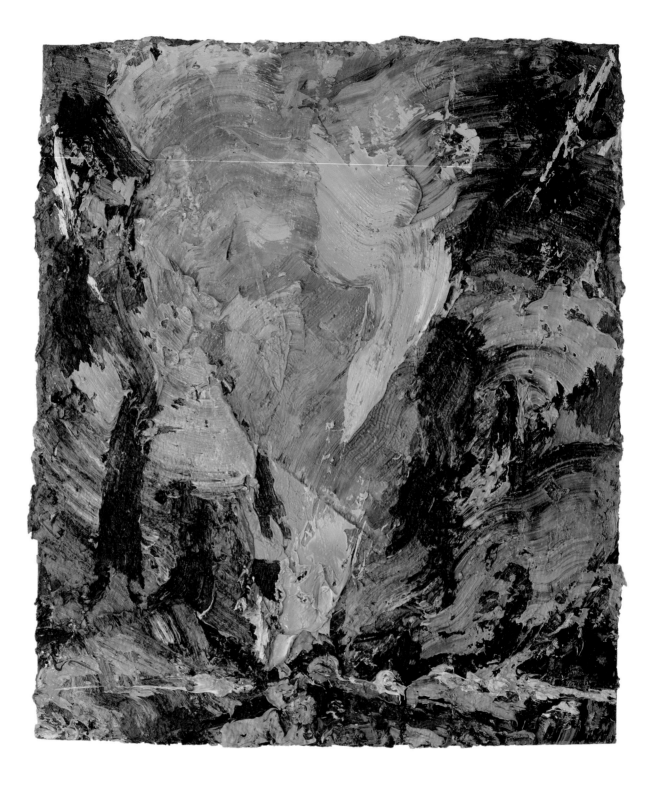

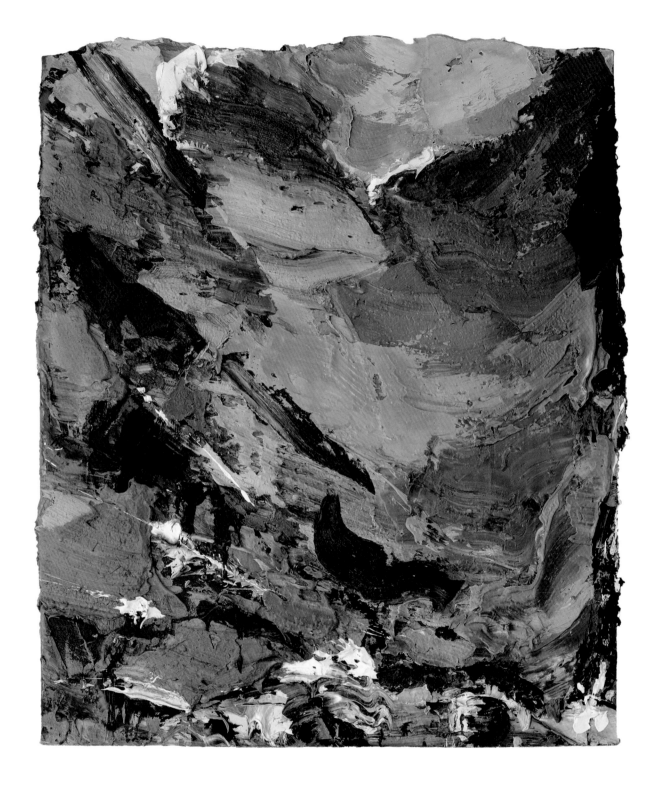

Skypiece
1996
Oil on cotton
55 × 47 inches
Artist's collection

44

Study for *Skypiece*
1996
Ink on paper
11 × 8½ inches
Artist's collection

Study for *Skypiece*
1996
Ink on paper
11 × 8½ inches
Artist's collection

Study for *Skypiece*
1996
Ink on paper
11 × 8½ inches
Artist's collection

OPPOSITE
Skypiece
1996
Oil on cotton
70⅞ × 51 inches
HGB Germany

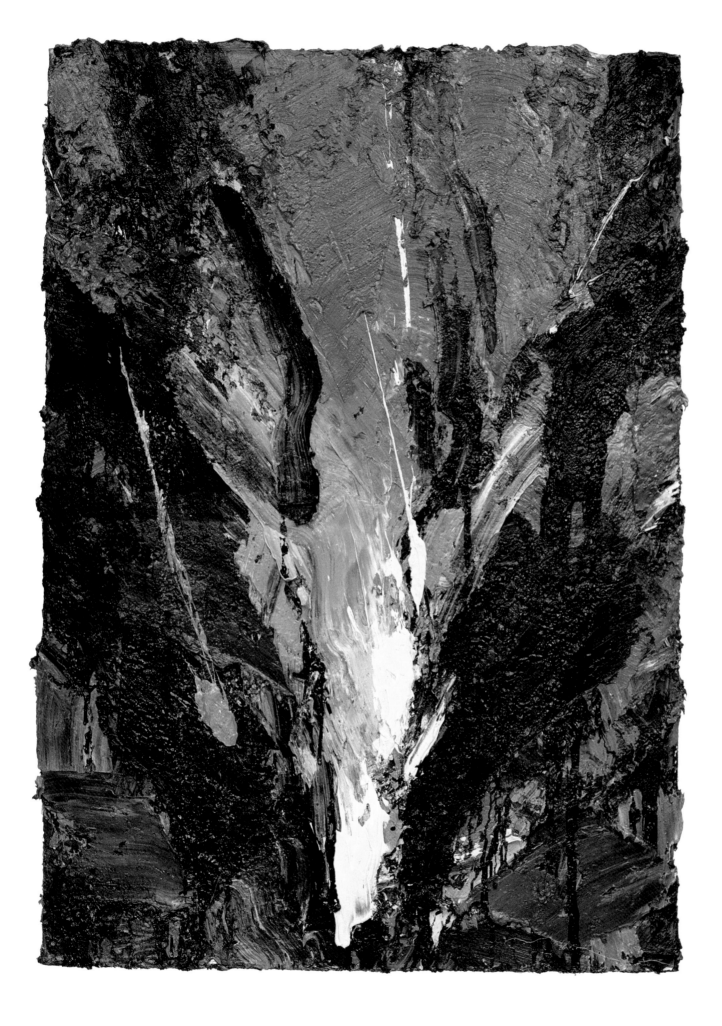

Skypiece
1996–97
Oil on cotton
63 × 51 inches
Private collection,
Hamburg

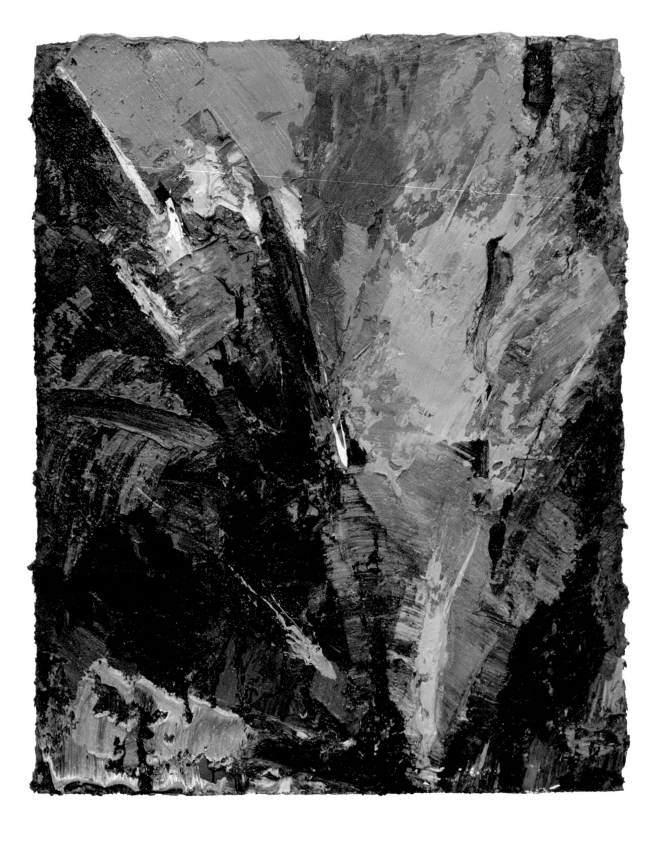

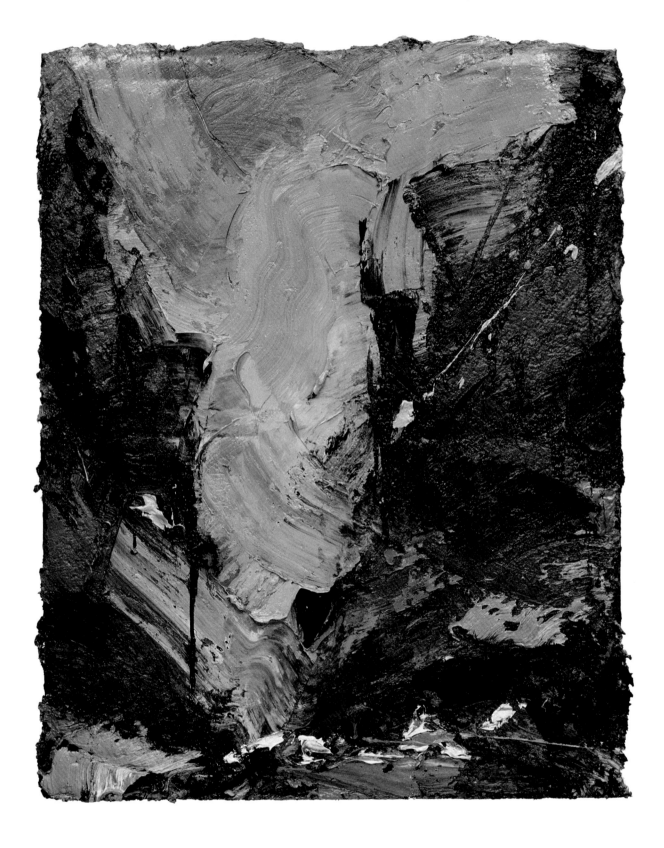

Skypiece
1999
Oil on cotton
63 × 52 inches
Artist's collection

Small Circles 1
1997
Oil on cotton
65 × 55 inches
Artist's collection

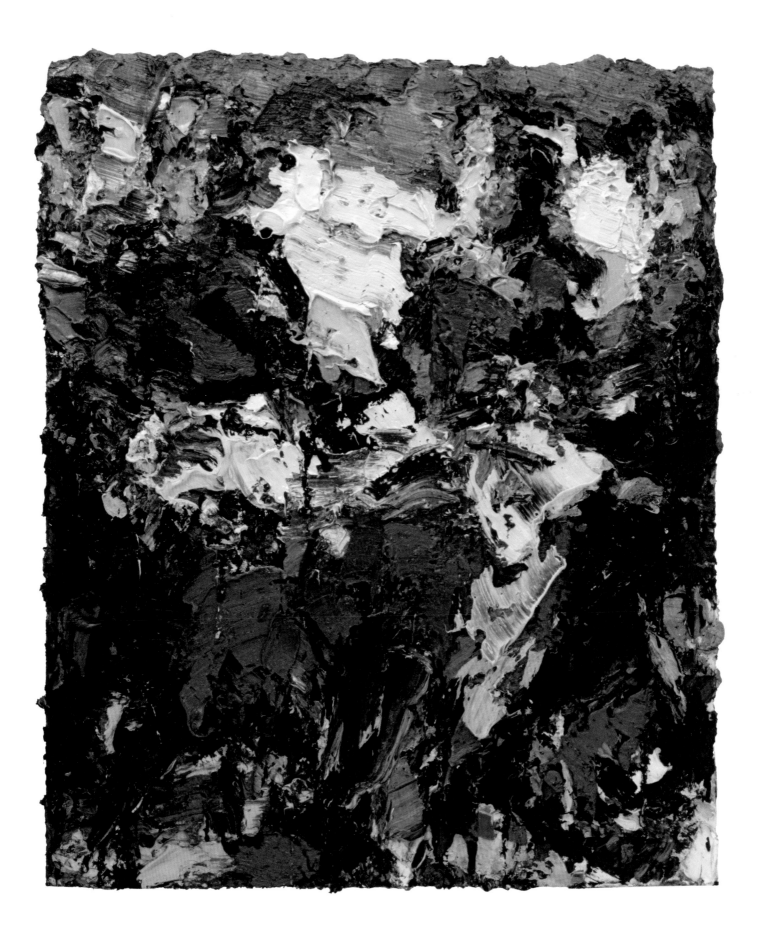

Random Cycles
1998
Oil on cotton
75 × 46 inches
Kingsborough Community
College, Brooklyn, NY

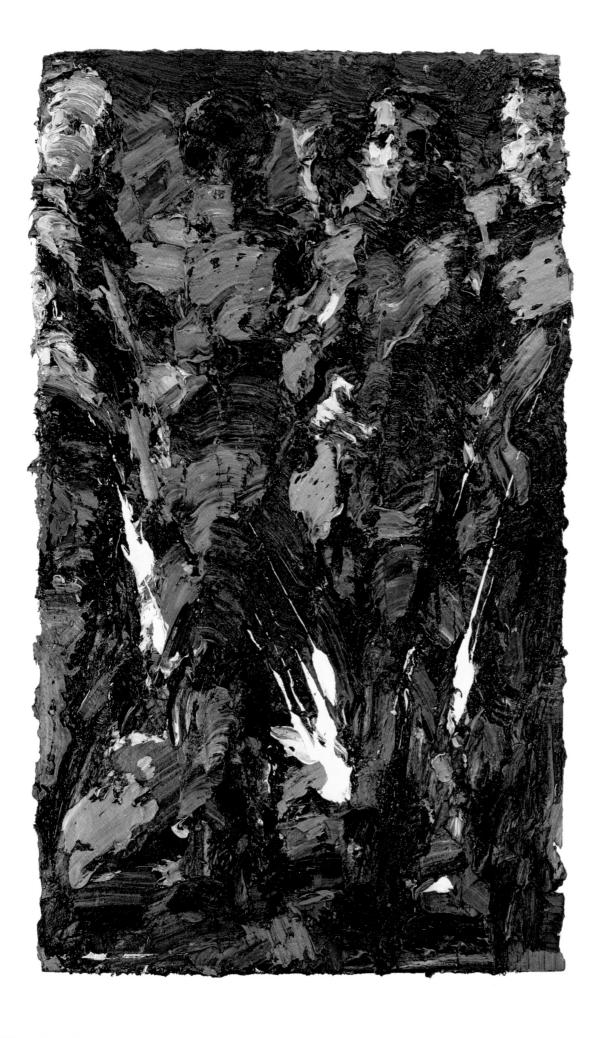

Portrait Irvin Dennis
1999
Oil on cotton
28 × 16 inches
Private collection,
New York

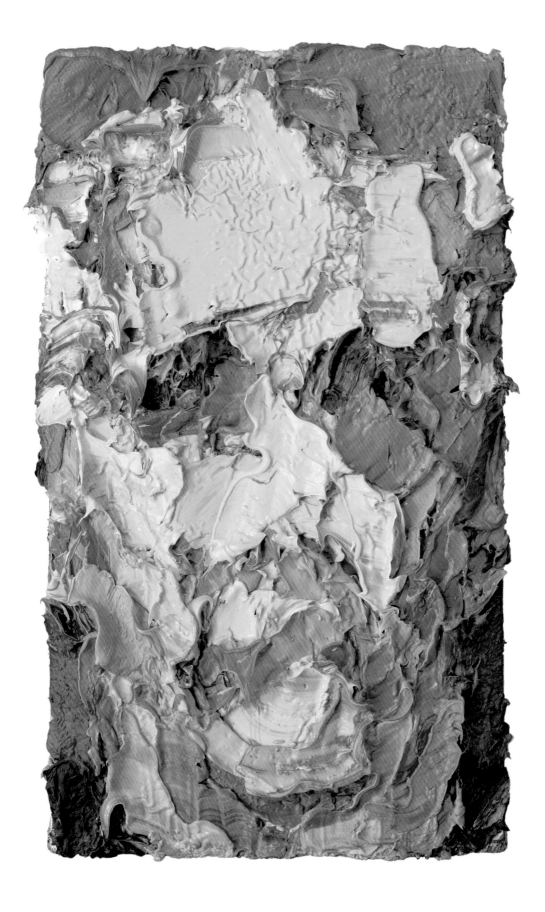

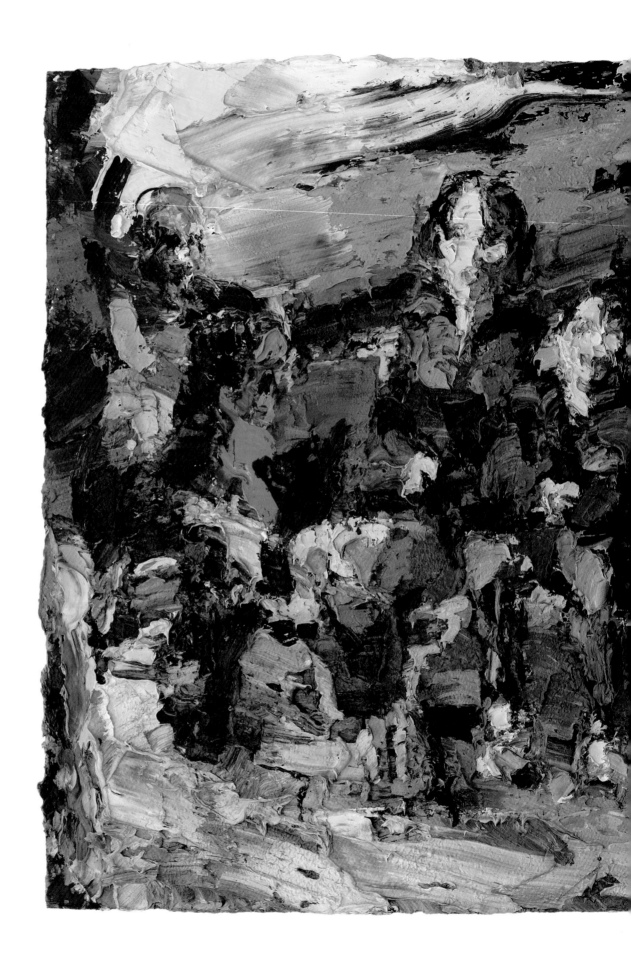

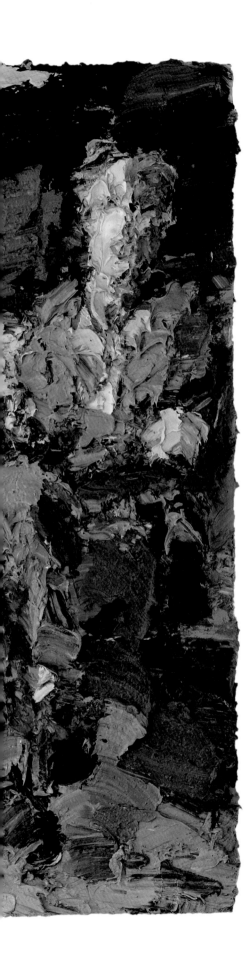

*Common Ground —
Florescent Run*
1998–99
Oil on cotton
65 × 70 inches
Artist's collection

58

Daily Drawing, 3/26/2003
Pigment and acrylics
on paper
30 × 22½ inches
Artist's collection

OPPOSITE
LEFT TO RIGHT
TOP TO BOTTOM

Daily Drawing, 07/14/1997

Daily Drawing, 12/22/1997

Daily Drawing, 07/26/1998

Daily Drawing, 12/17/1998

Daily Drawing, 11/02/1999

Daily Drawing, 01/28/2000

Daily Drawing, 01/27/2001

Daily Drawing, 07/01/2003

Daily Drawing, 10/01/2003

Each: Mixed media
on paper
30 × 22½ inches
Artist's collection

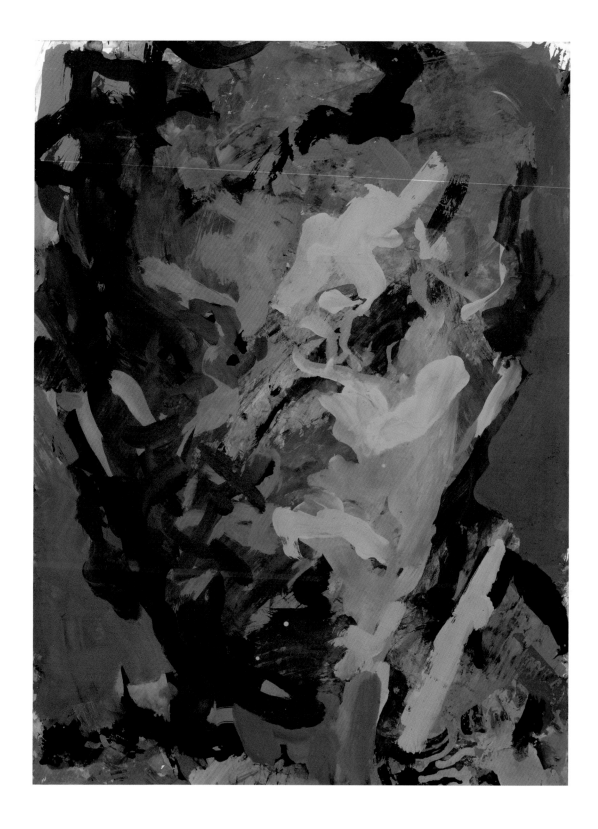

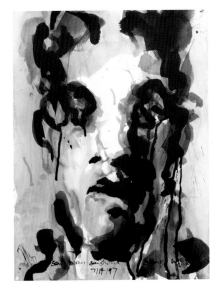

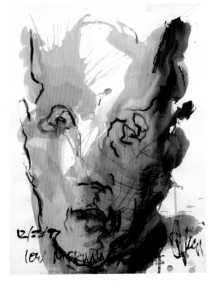

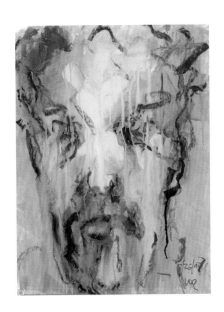

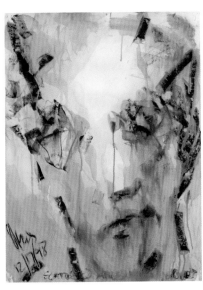

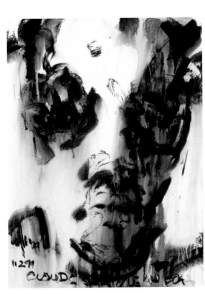

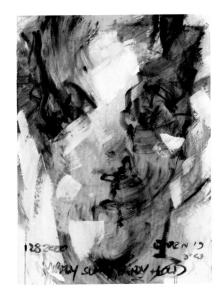

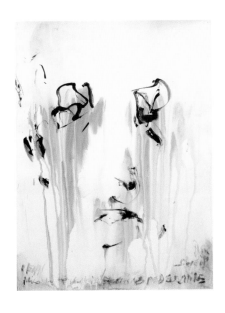

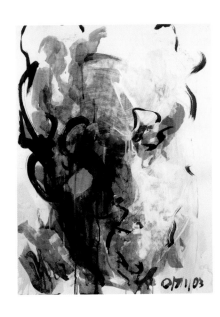

Ronald
1999
Oil on cotton
28 × 16 inches
Ronald Fagan collection,
New York

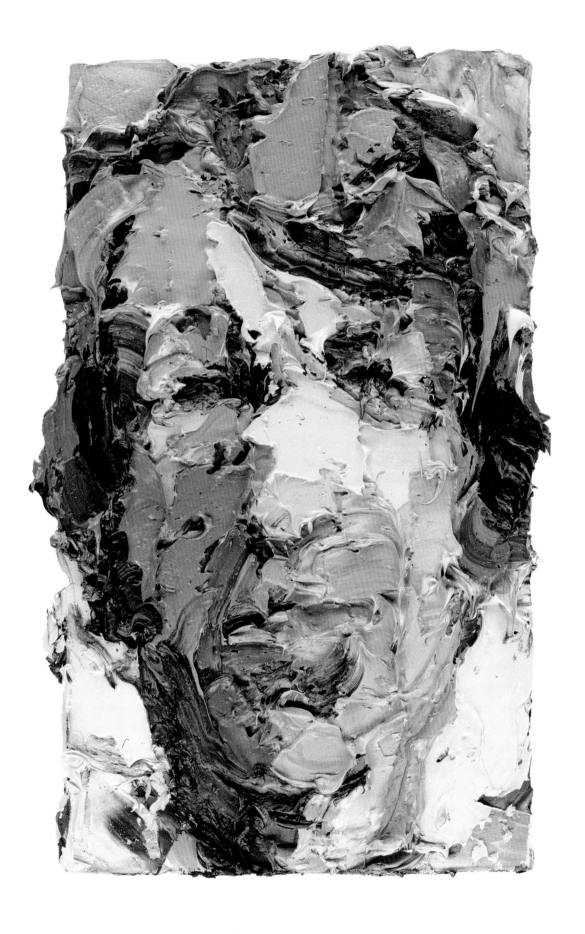

*Random Cycles —
Short Shots*
1999
Oil on cotton
71 × 66 inches
Stern collection

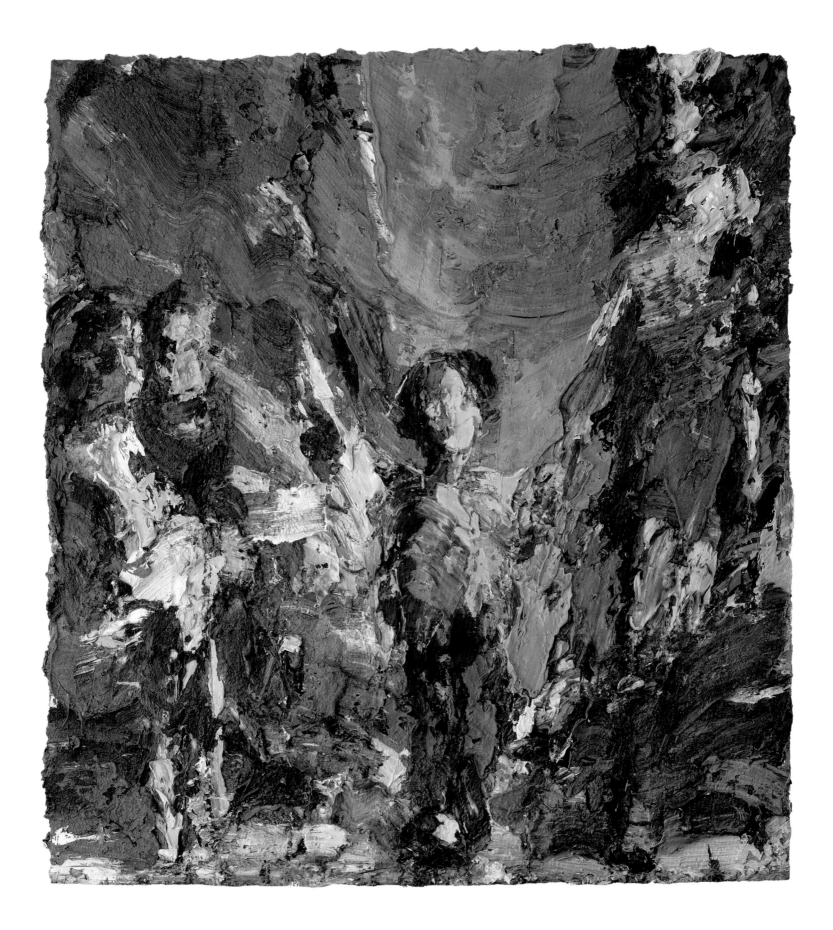

Random Cycles —
Stand on Down
1999
Oil on cotton
75 × 37 inches
Ochendalsky collection,
Cologne, Germany

Igor
1999
Oil on cotton
28 × 16 inches
Private collection,
New York

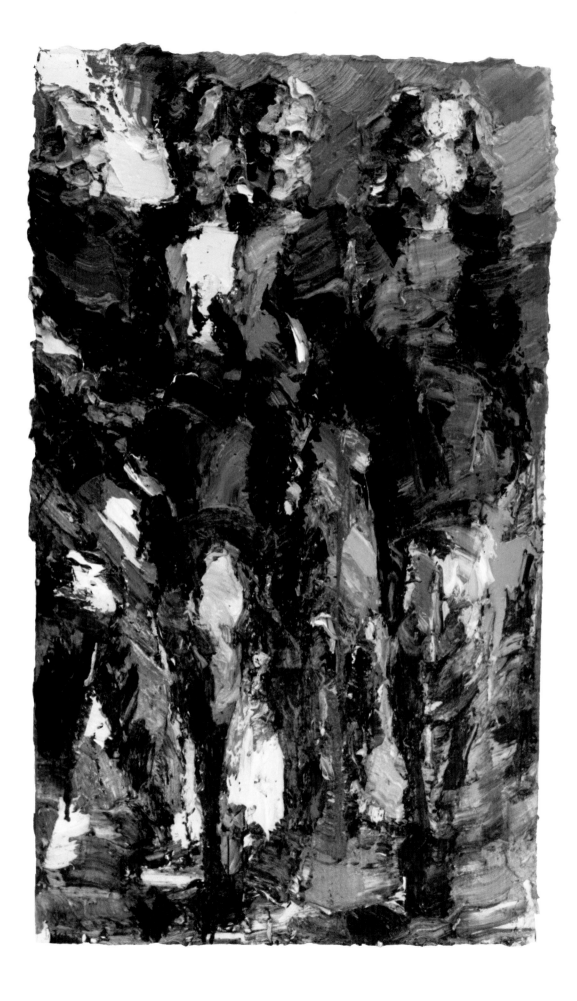

Random Cycles—
High Skies Down
1999
Oil on cotton
75 × 46 inches
Private collection

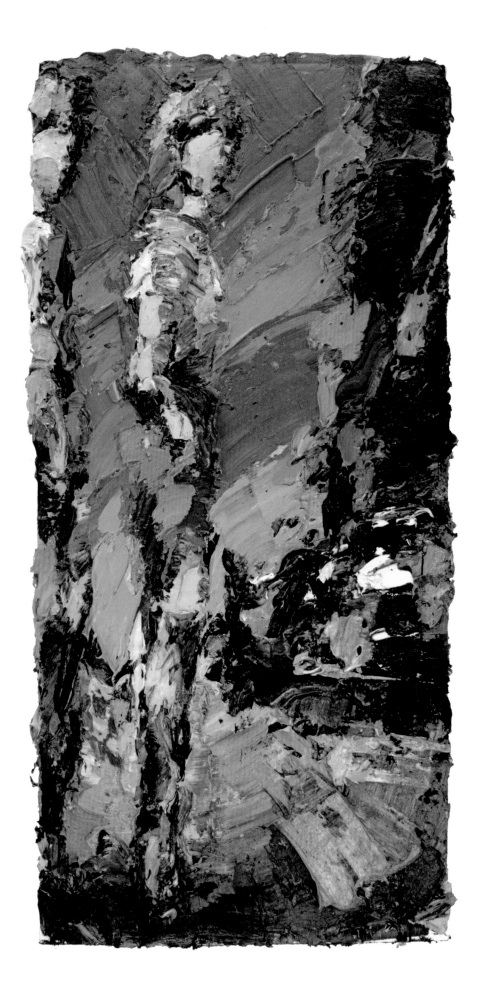

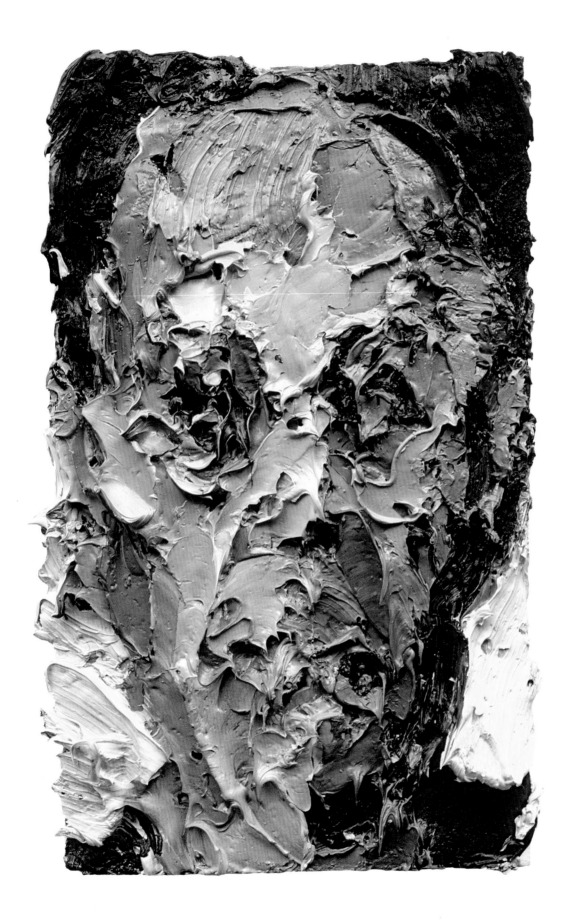

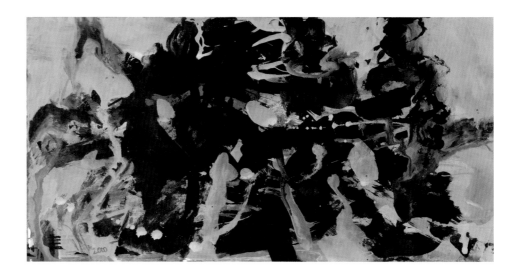

Study for *Small Circles*
(Bacciale)
2000
Ink and acrylics on paper
11 × 22 inches
Artist's collection

Study for *Small Circles*
2000
Ink and acrylics on paper
19 × 22 inches
Artist's collection

OPPOSITE
Small Circles
1998
Oil on cotton
65 × 55 inches
Collection Joachim Graf,
Essen, Germany

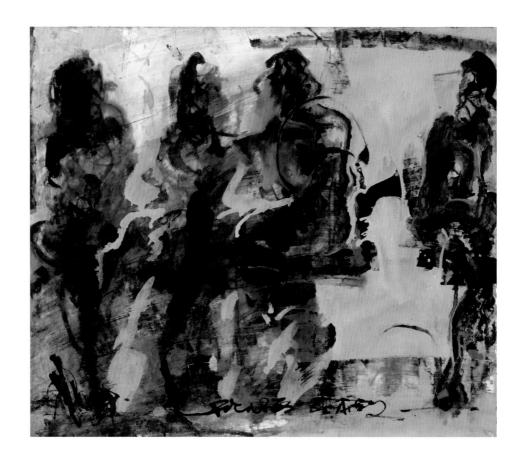

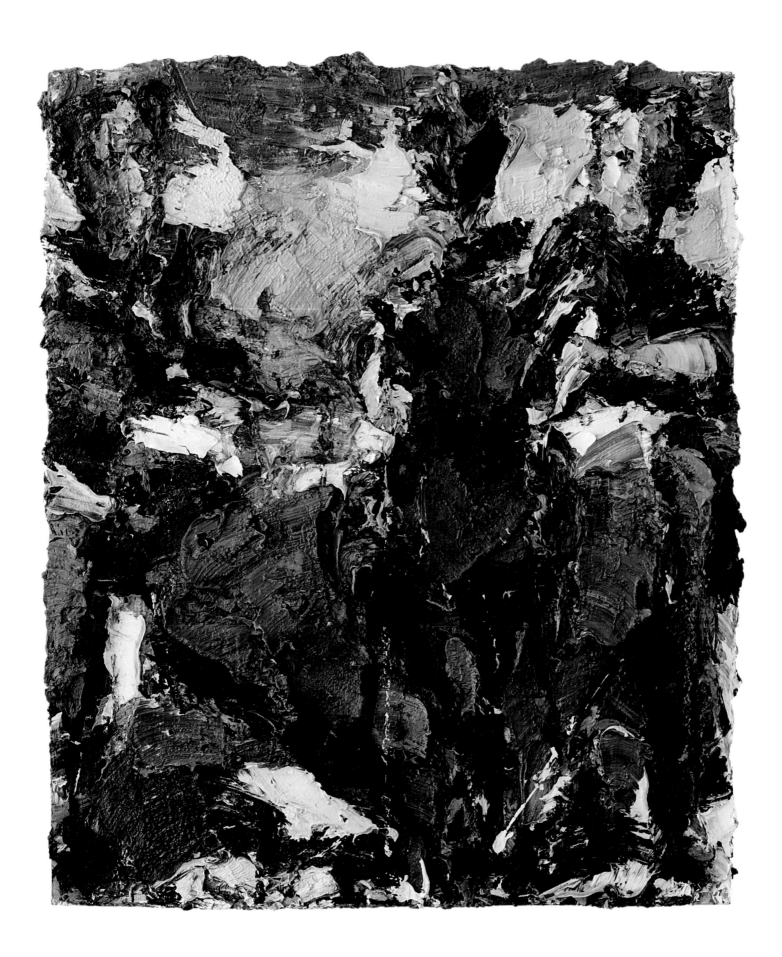

Skypiece 3
Sundown New Jersey
2000
Oil on cotton
42 × 37 inches
Private collection,
Bad Homburg v.d.H.,
Germany

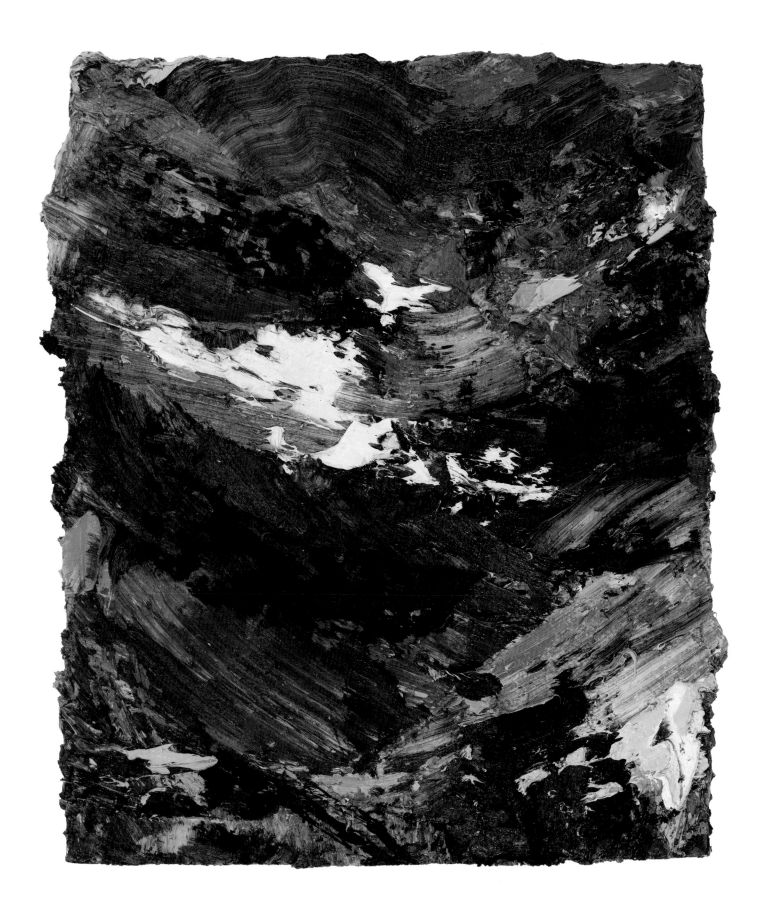

Coco 1
2000
Oil on cotton
28 × 16 inches
Private collection,
Munich

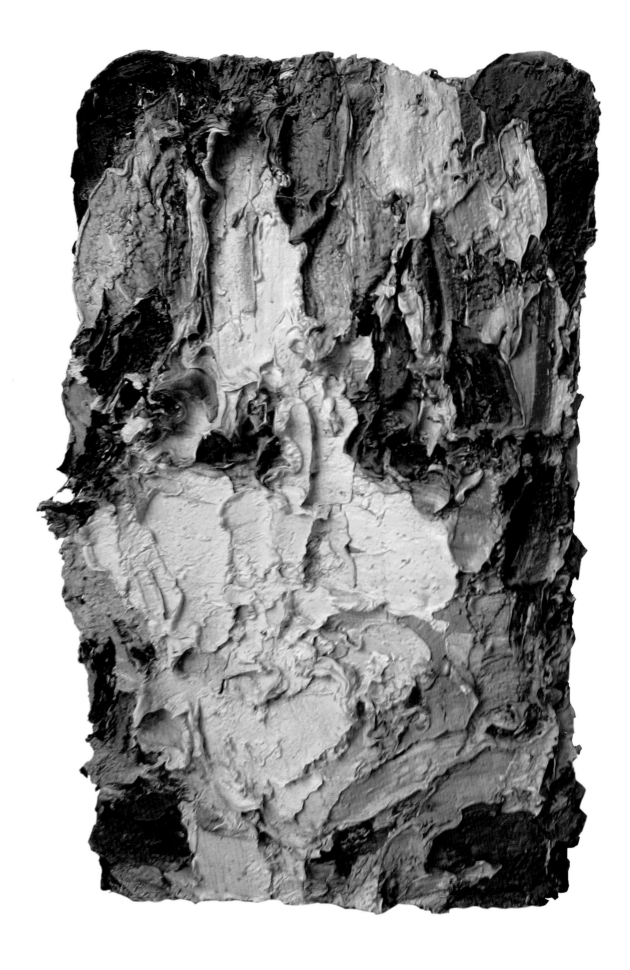

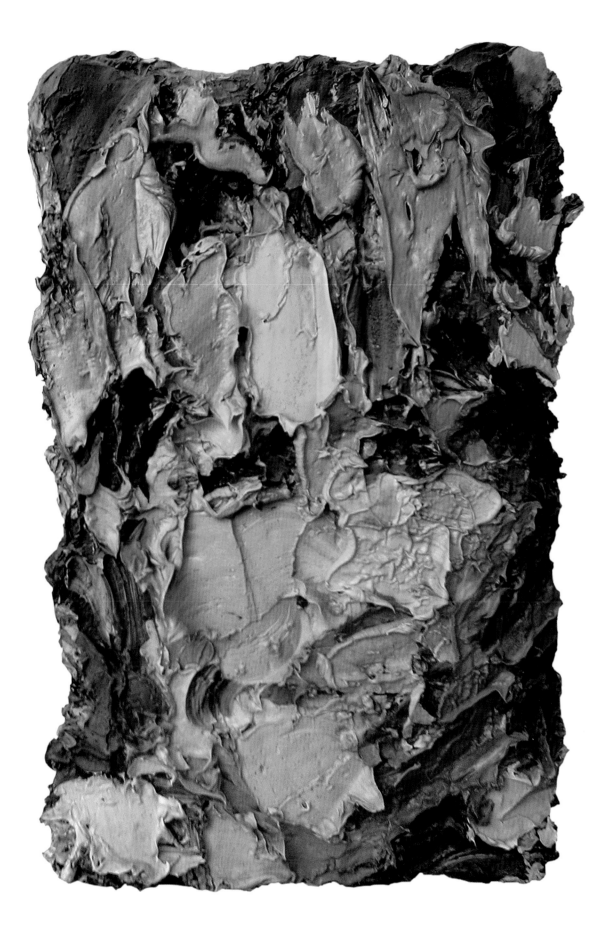

Coco 2
2000
Oil on cotton
28 × 16 inches
Private collection,
Munich

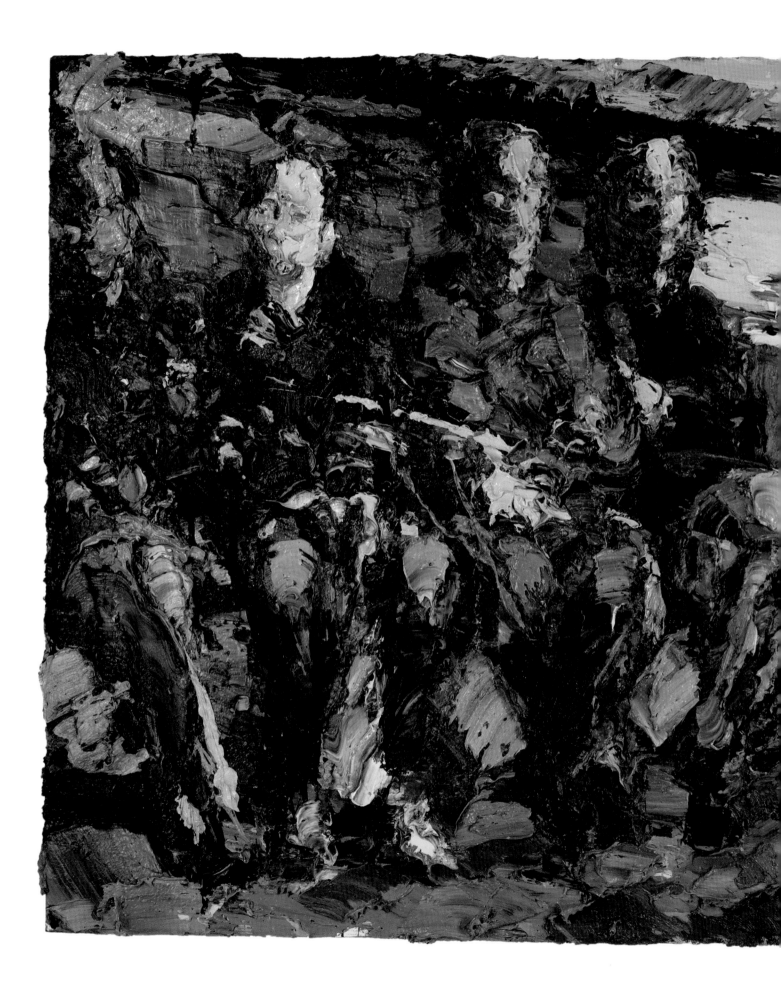

Square Times
(Common Ground)
2000
Oil on Cotton
65 × 81 inches
HGB Germany

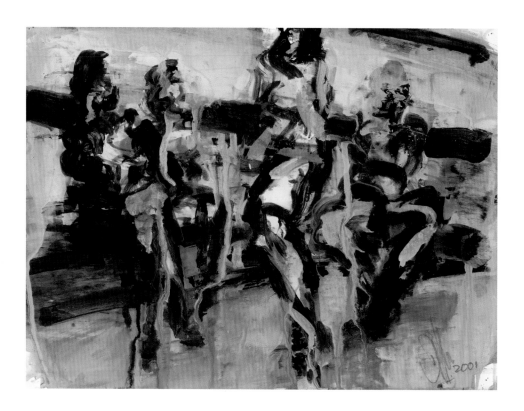

Study for *Common Ground*
2001
Ink and acrylics on paper
11 × 15 inches
Artist's collection

OPPOSITE

Common Ground —
On the Shores of Little Italy
2000
Oil on cotton
65 × 56 inches
Lyasso-Collection, Cologne,
Germany and HGB Germany

Standing Figure (Rachel)
2001
Oil on cotton
72 × 31 inches
Artist's collection

Skypiece — SoHo 2
2001
Oil on cotton
36 × 25 inches
Private collection,
New York

Skypiece — SoHo 1
2001
Oil on cotton
36 × 25 inches
Stern collection

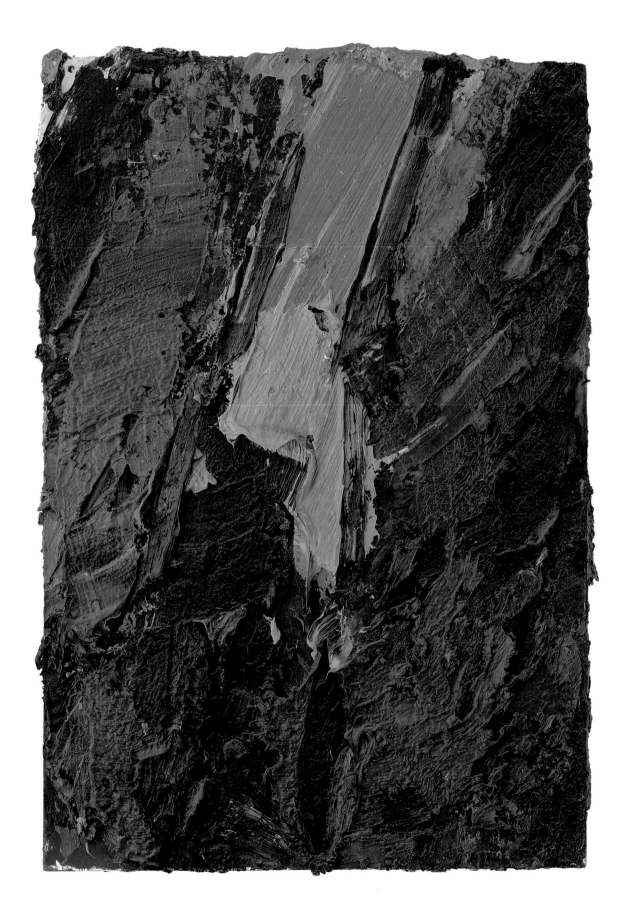

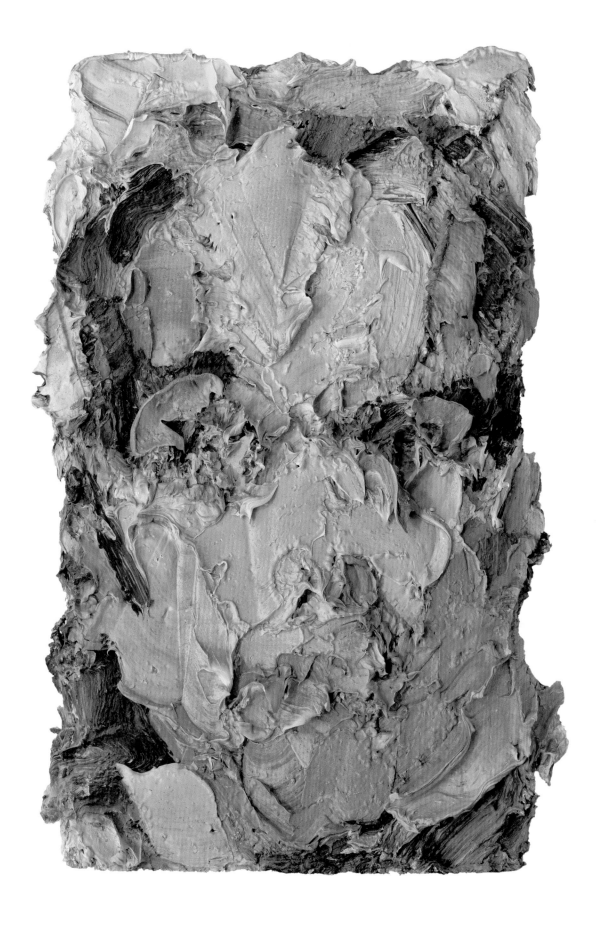

Dominique
2000
Oil on cotton
28 × 16 inches
Courtesy Dominique Nahas

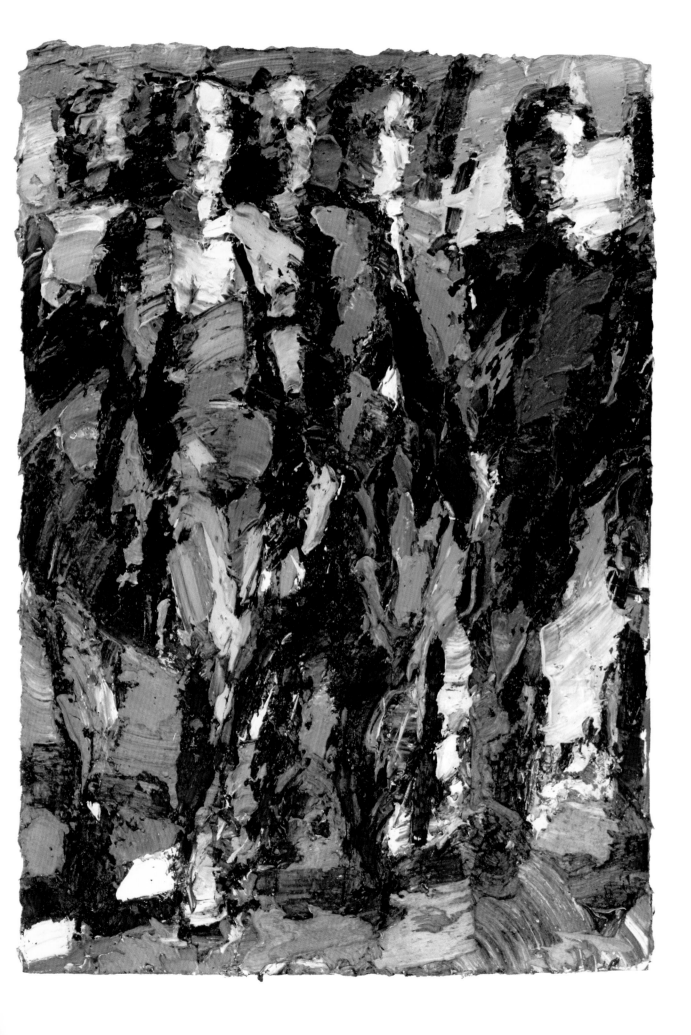

Random Cycles—
Wide Eye Shuffle
(diptych, right)
2000
Oil on cotton
81 × 61 inches
Private collection

Random Cycles —
Wide Eye Shuffle
(diptych, left)
2000
Oil on cotton
81 × 61 inches
Private collection

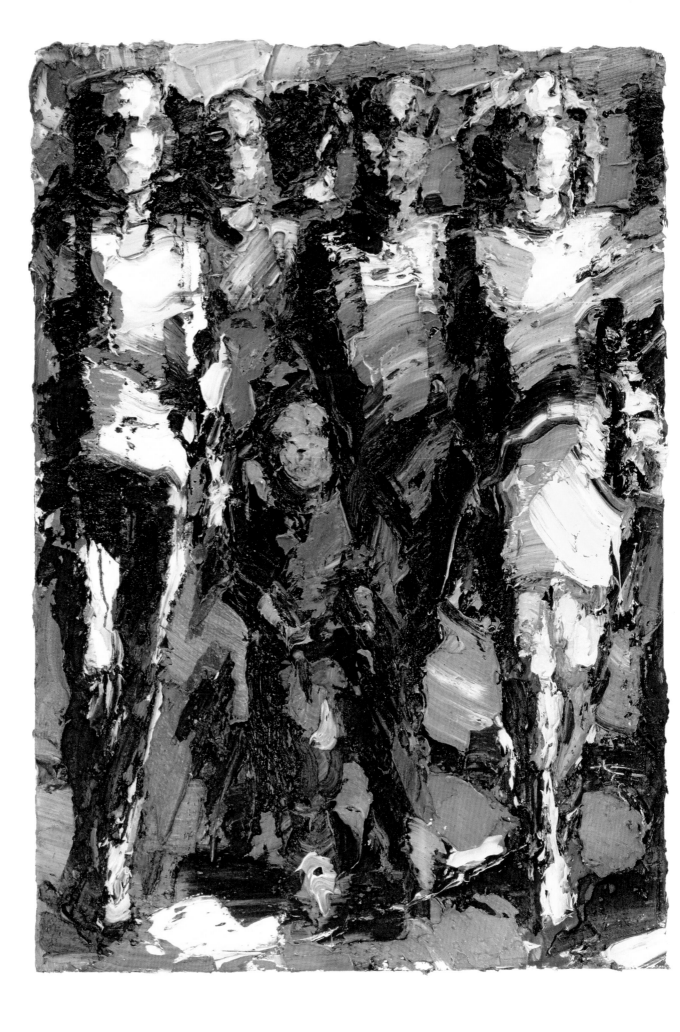

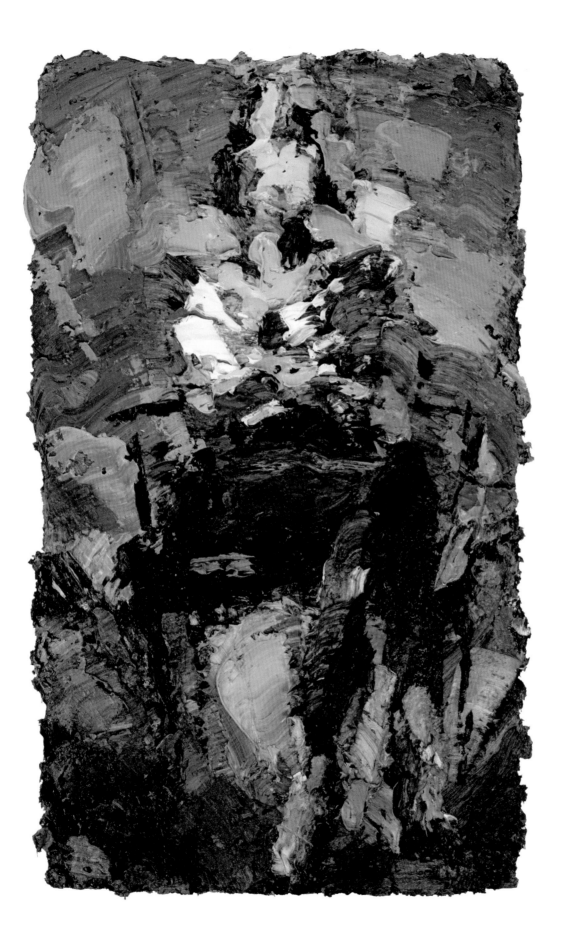

Coco
2000
Oil on cotton
60 × 36 inches
Private collection

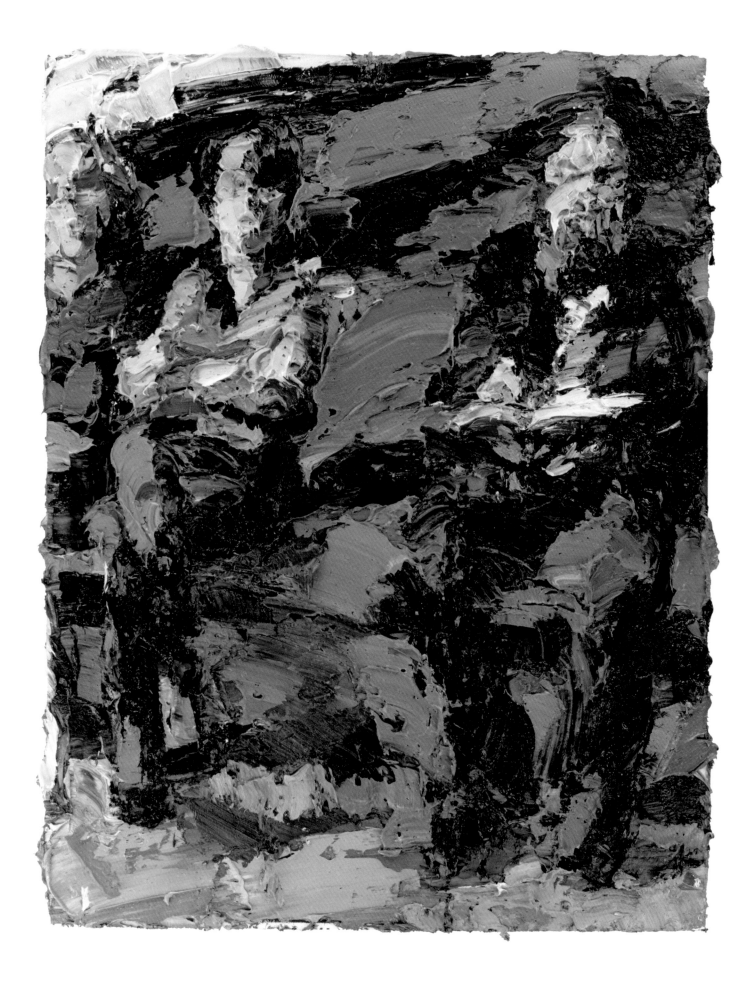

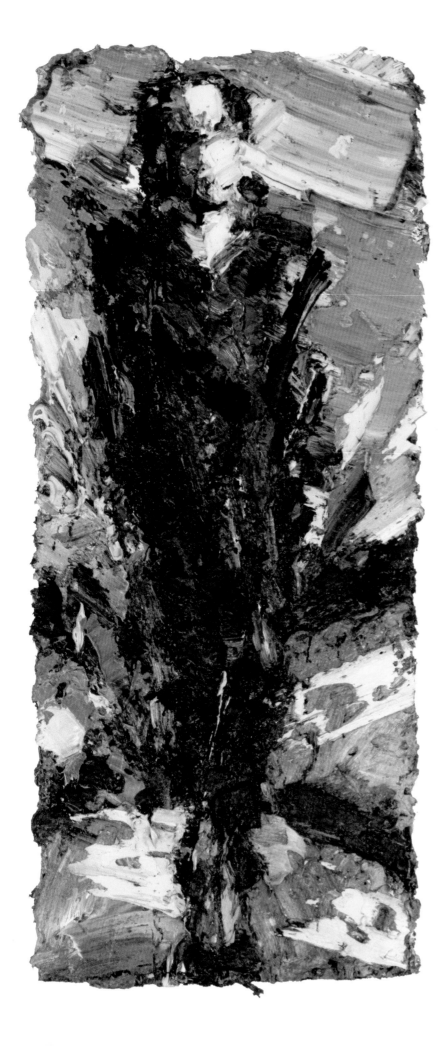

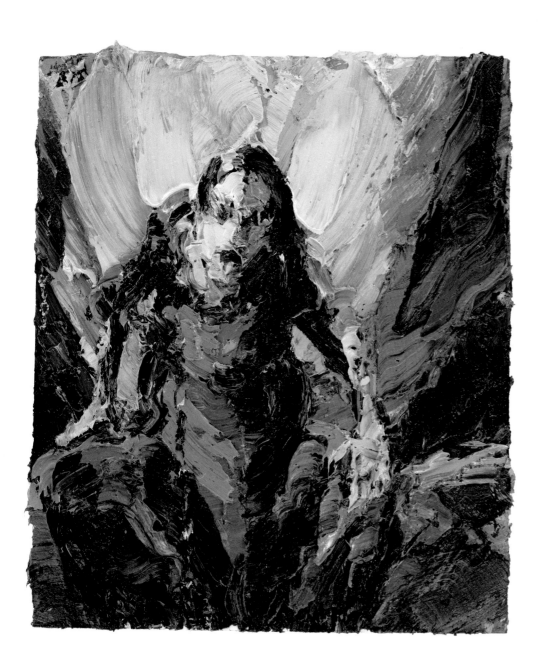

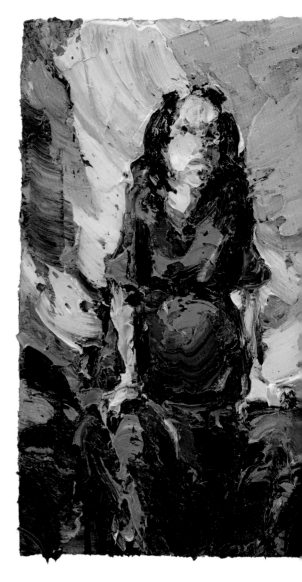

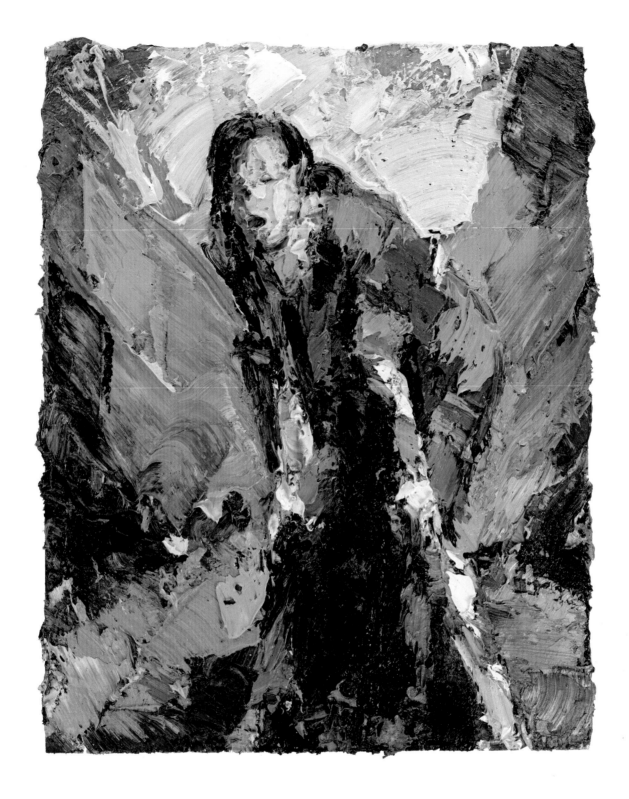

LEFT TO RIGHT

Woman in Labor
2001
Oil on cotton
63 × 52 inches
Private collection,
New York

Woman in Labor
2001
Oil on cotton
49 × 45 inches
Private collection,
New York

Woman in Labor
2001
Oil on cotton
55 × 47 inches
Stern collection

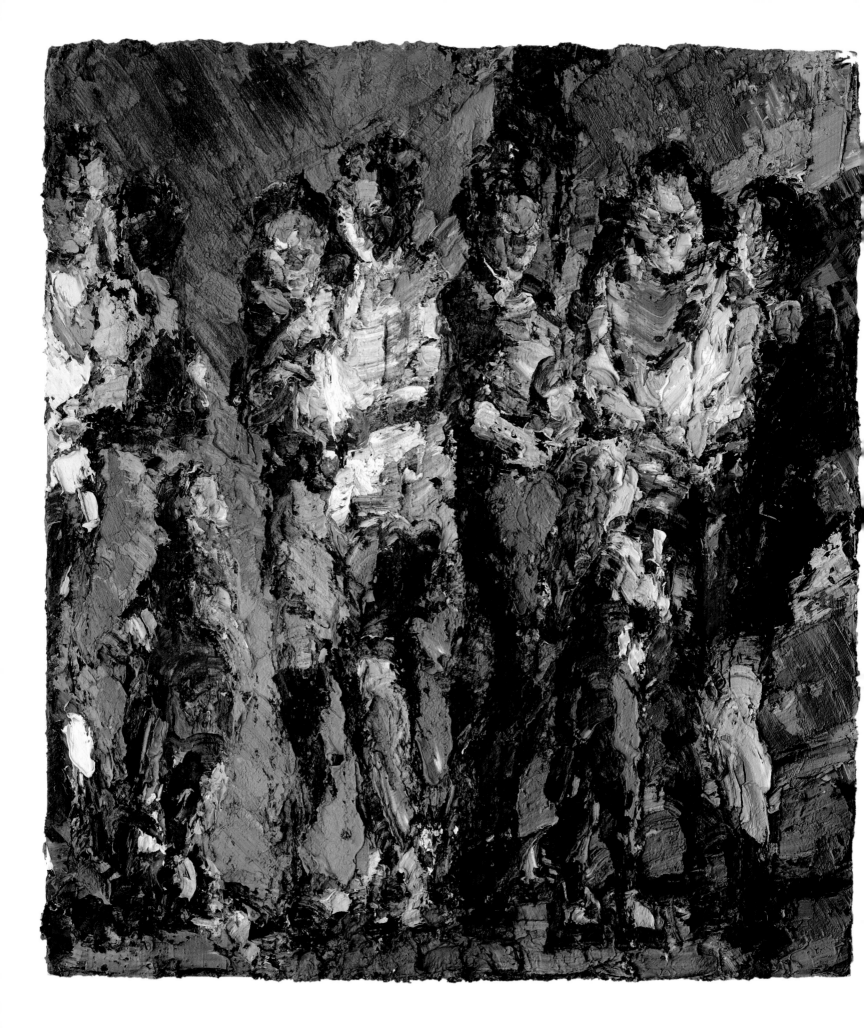

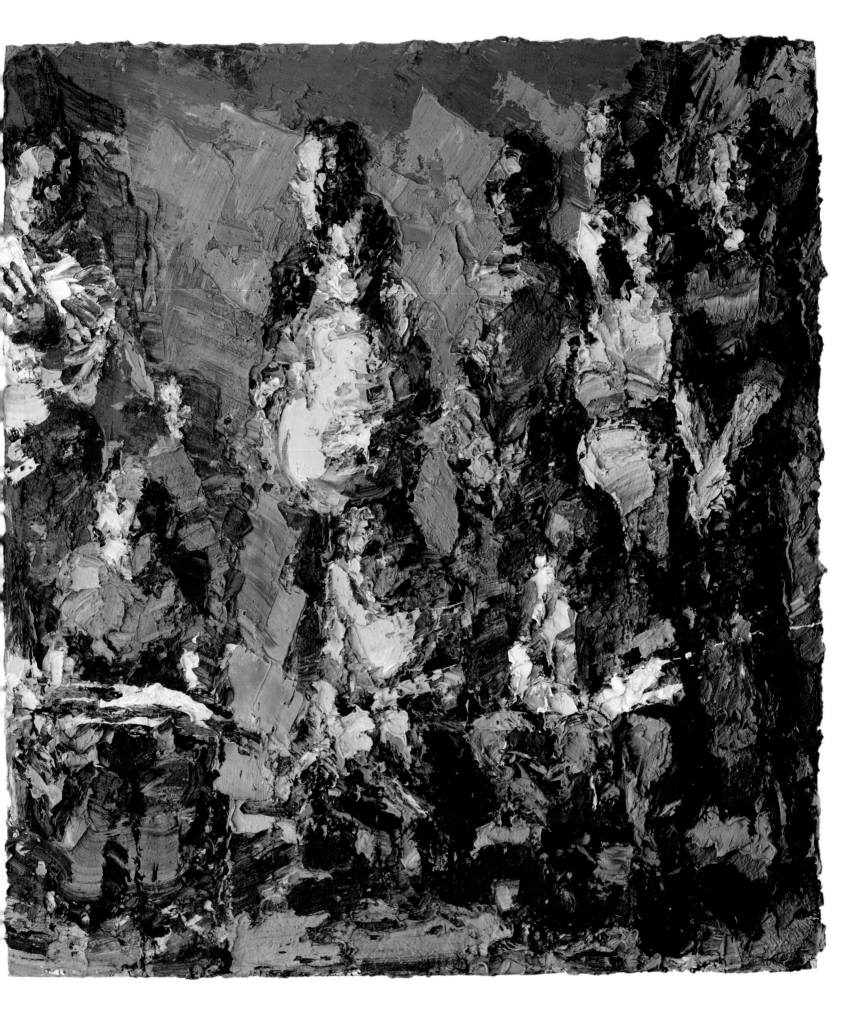

94

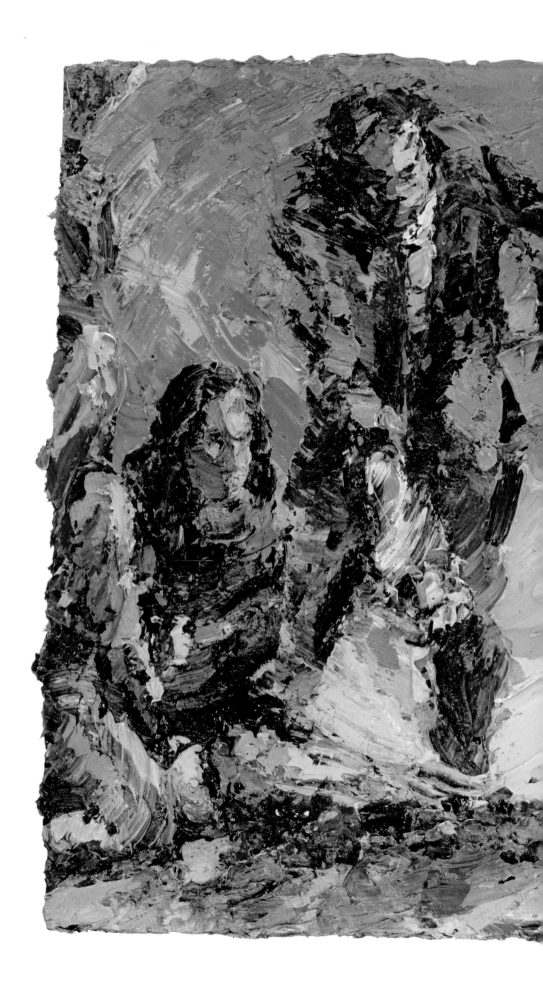

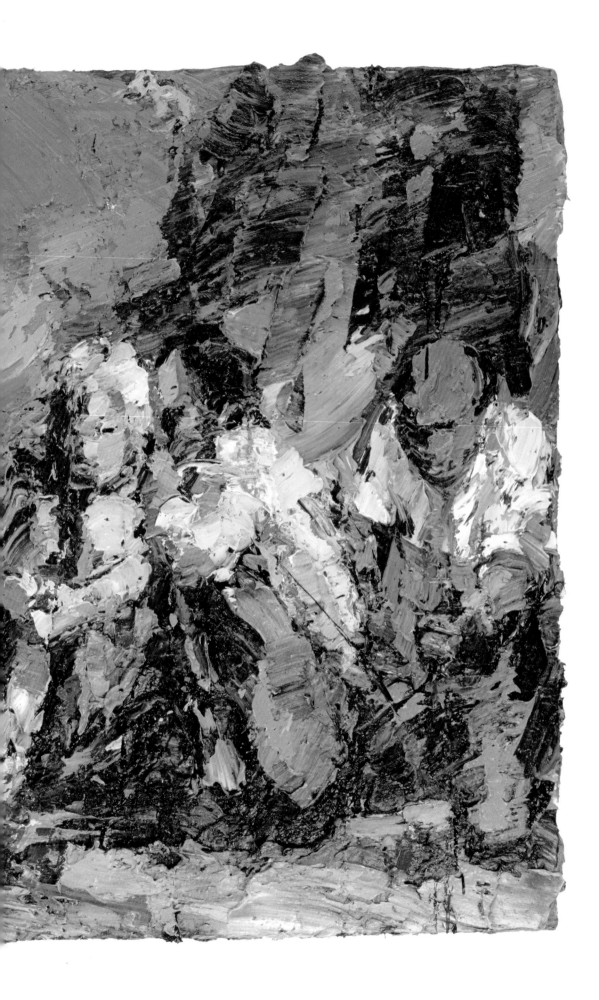

*September Skies — To the
Rafters*
2003
Oil on cotton
75 × 58 inches
Artist's collection

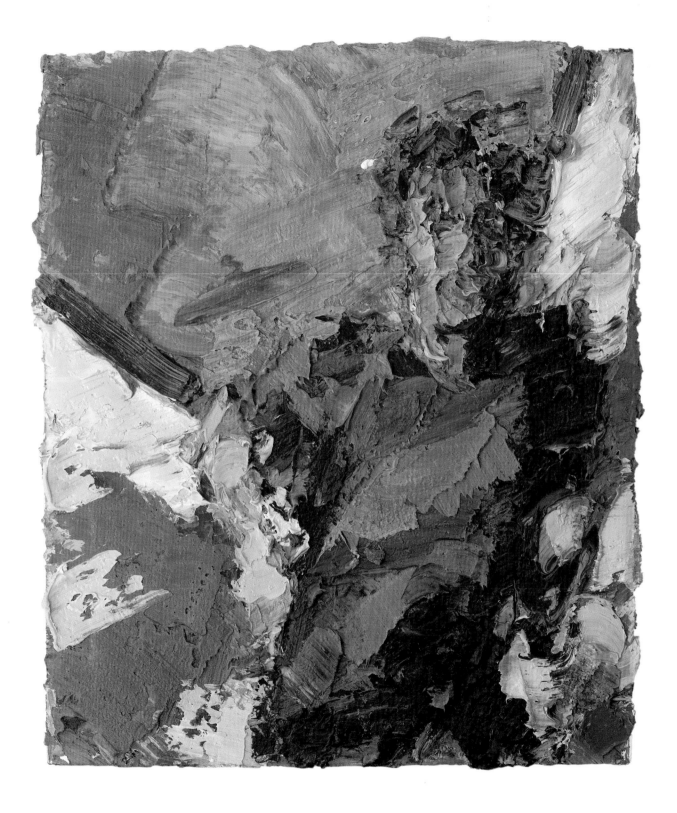

Braces and Shadows 1
2003
Oil on cotton
43 × 36 inches
Artist's collection

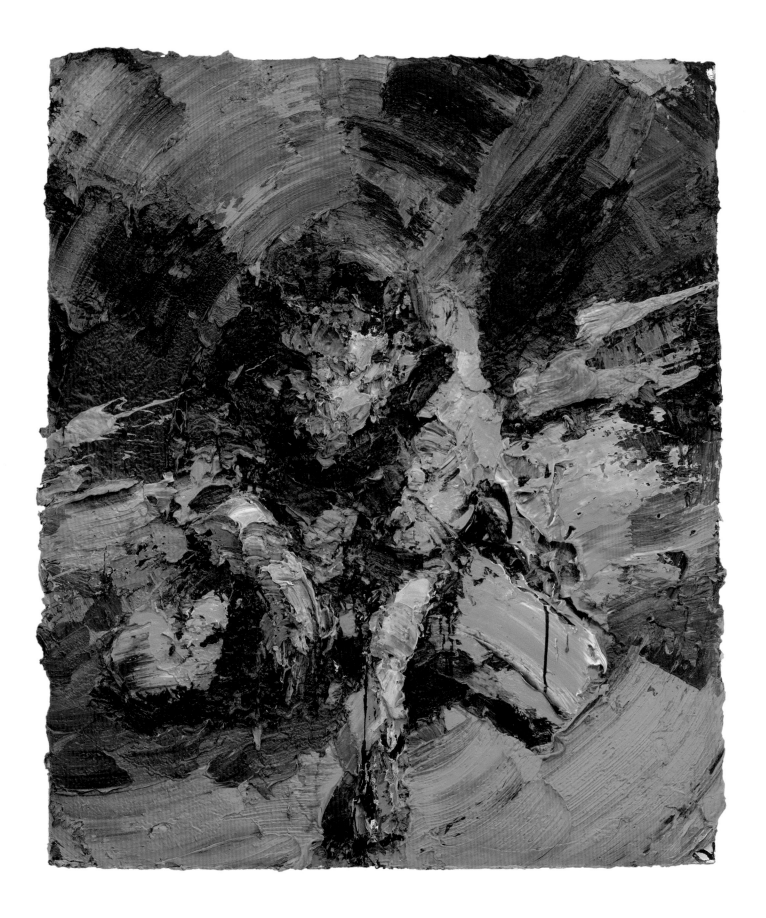

98

Scotch and Orange
2002
Oil on cotton
42 × 36 inches
Private collection,
New York

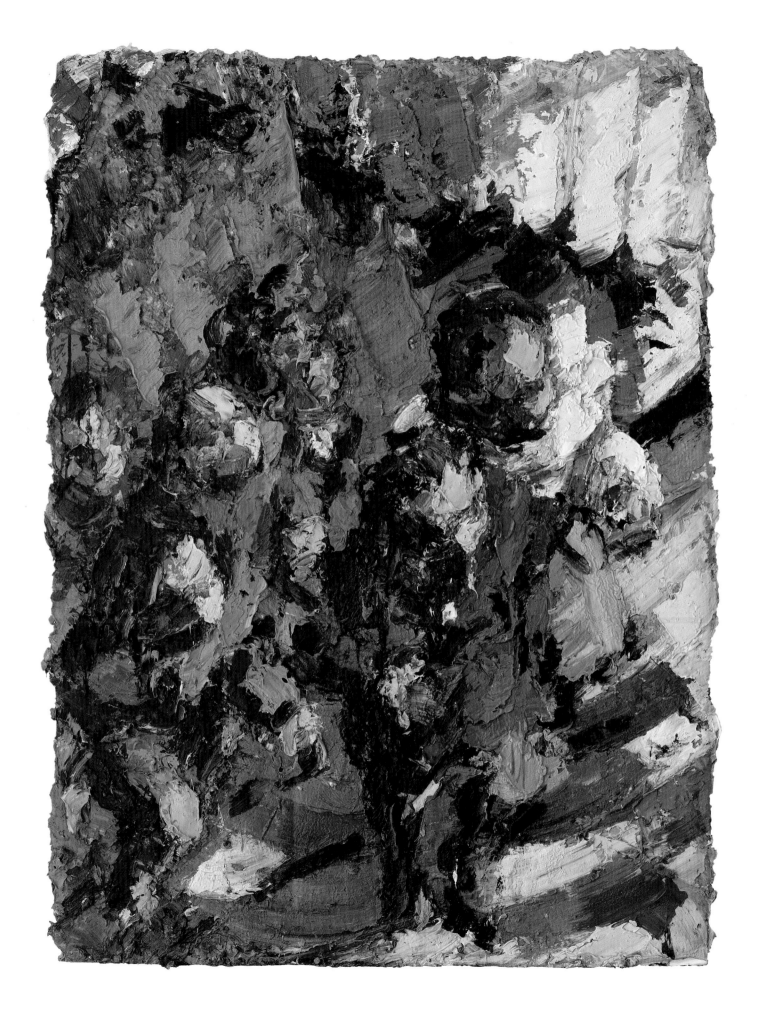

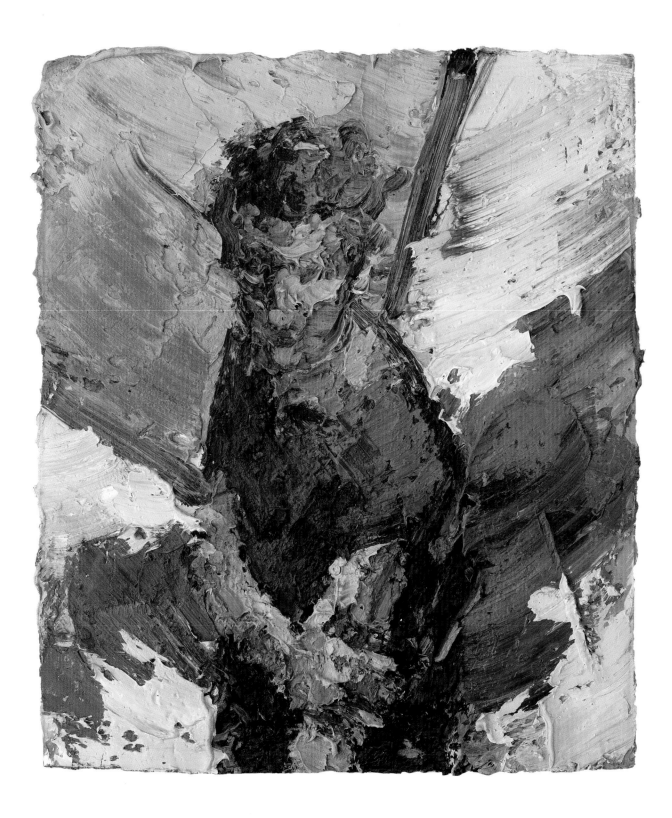

Braces and Shadows 2
2003
Oil on cotton
43 × 36 inches
Artist's collection

**FOLLOWING PAGES
LEFT TO RIGHT**

Braces and Shadows 3
2003
Oil on cotton
47 × 40 inches
Artist's collection

Braces and Shadows 4
2003
Oil on cotton
47 × 40 inches
Artist's collection

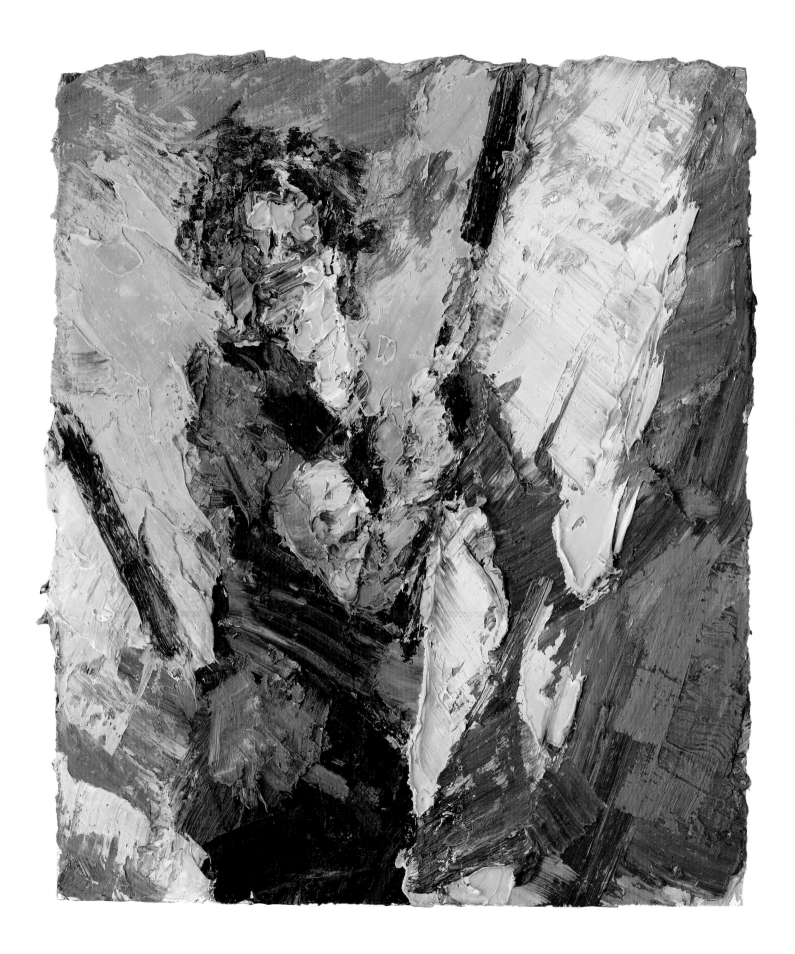

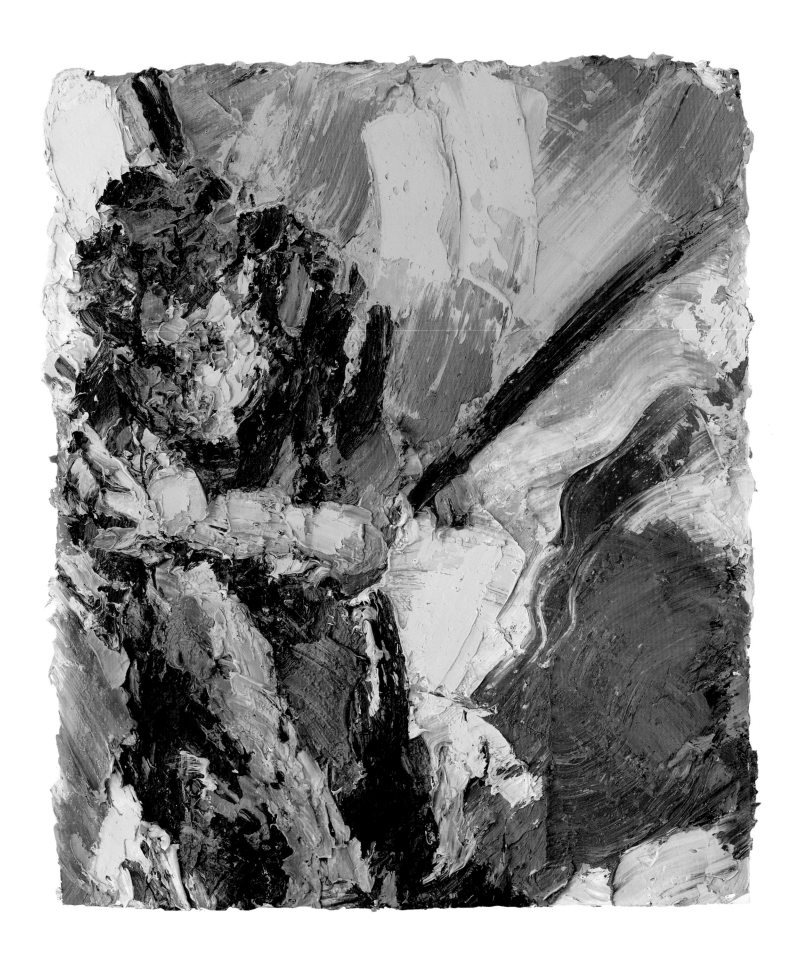

Braces and Shadows
2003
Oil on cotton
62 × 37 inches
Artist's collection

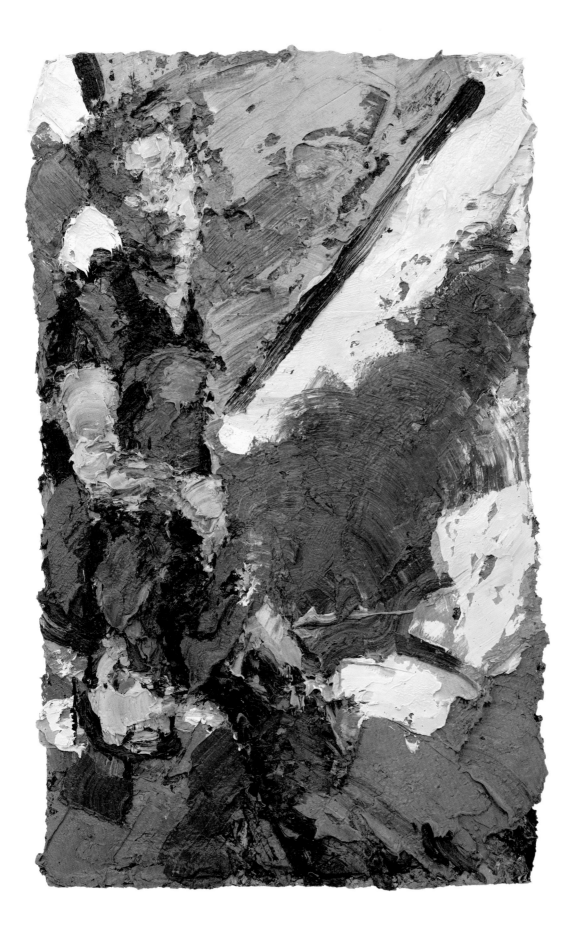

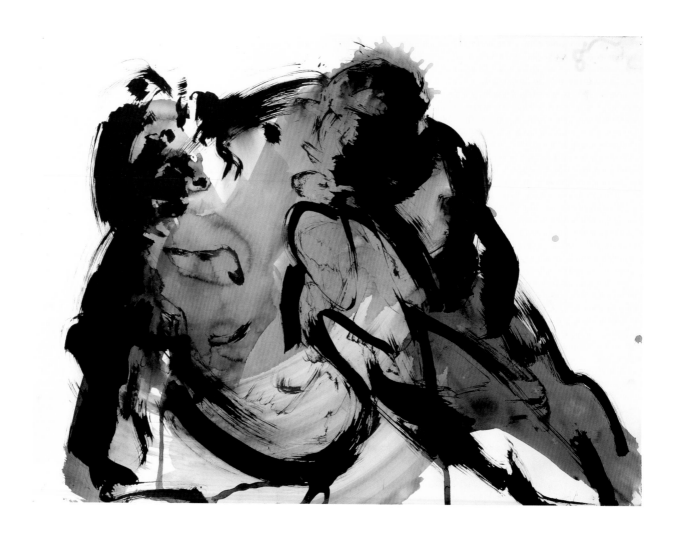

Figure study for
*Tribute to Gus
and Harry*
2003
Ink and acrylics
on paper
22½ × 30 inches
Artist's collection

OPPOSITE
*Tribute to Gus
and Harry*
2003–04
Oil on cotton
48 × 61 inches
Private collection

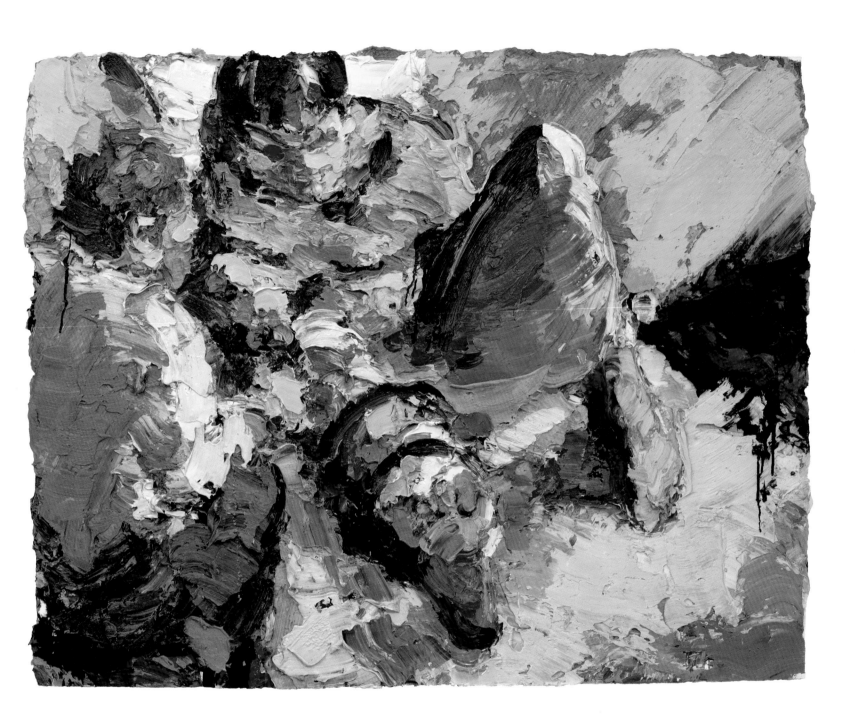

Two (Braces and Shadows)
2003
Oil on cotton
28 × 37 inches
Private collection,
New York

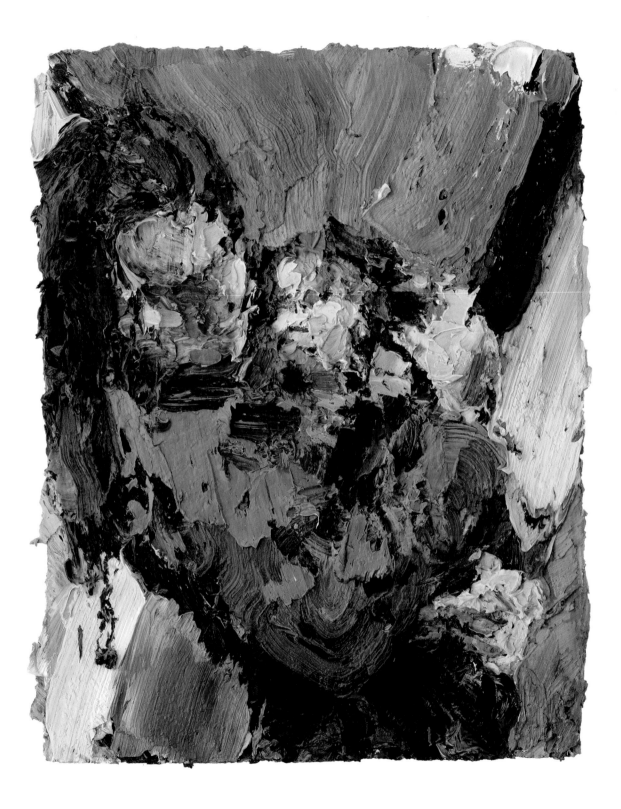

Marvin and Frank
2001–02
Oil on cotton
61 × 49 inches
Artist's collection

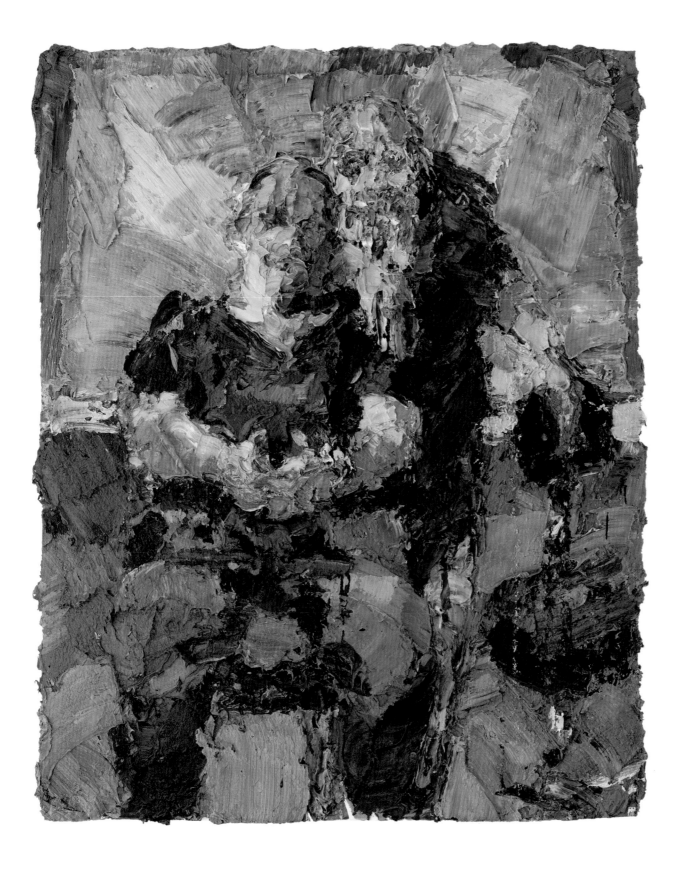

Val
2002
Oil on cotton
60 × 36 inches
Artist's collection

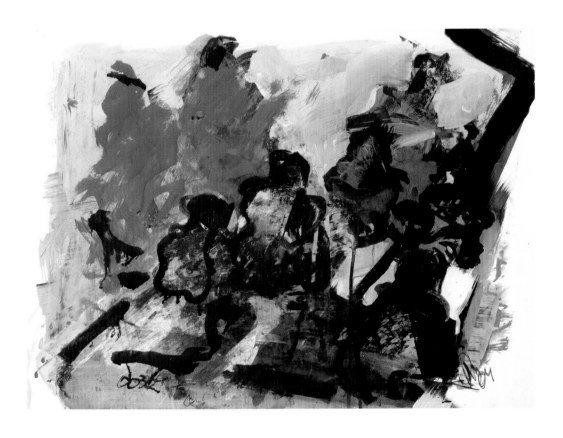

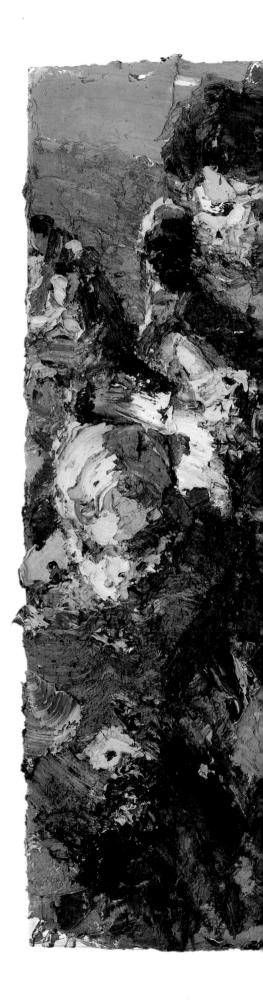

Study for *Dallas BBQ*
2004
Ink and acrylics
on paper
22 × 30 inches
Artist's collection

Dallas BBQ
2004
Oil on cotton
71 × 81 inches
Artist's collection

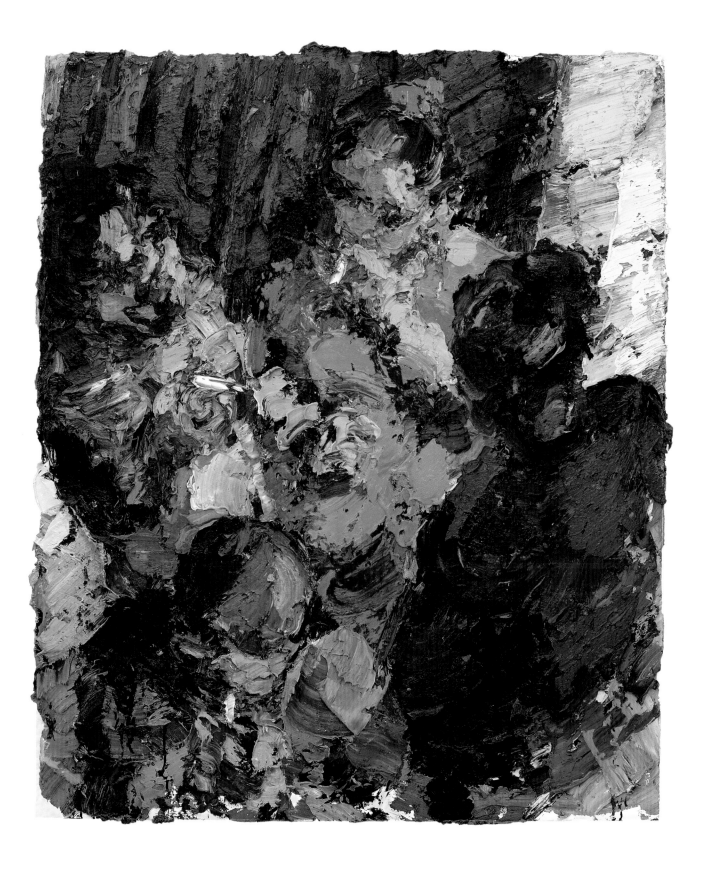

Smokers
2004
Oil on cotton
56 × 47 inches
Artist's collection

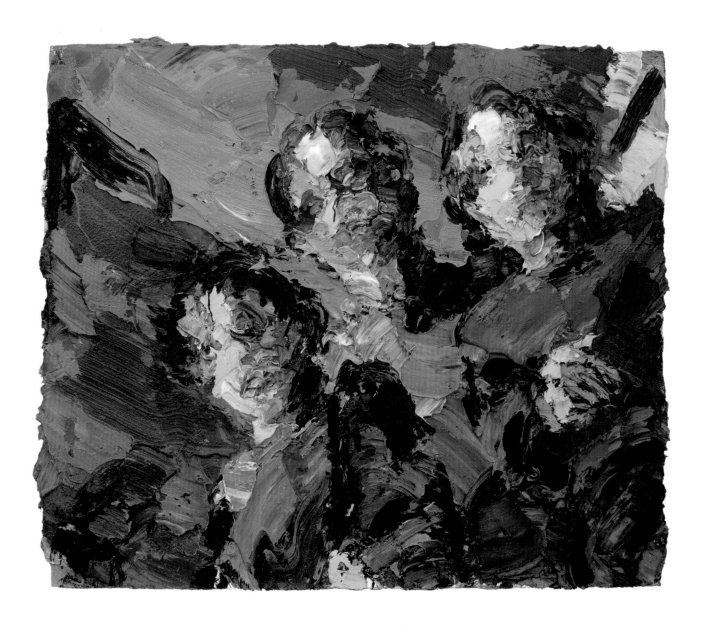

September Skies
2003–04
Oil on cotton
56 × 47 inches
Segall collection

OPPOSITE
September Skies
2003–04
Oil on cotton
75 × 56 inches
Artist's collection

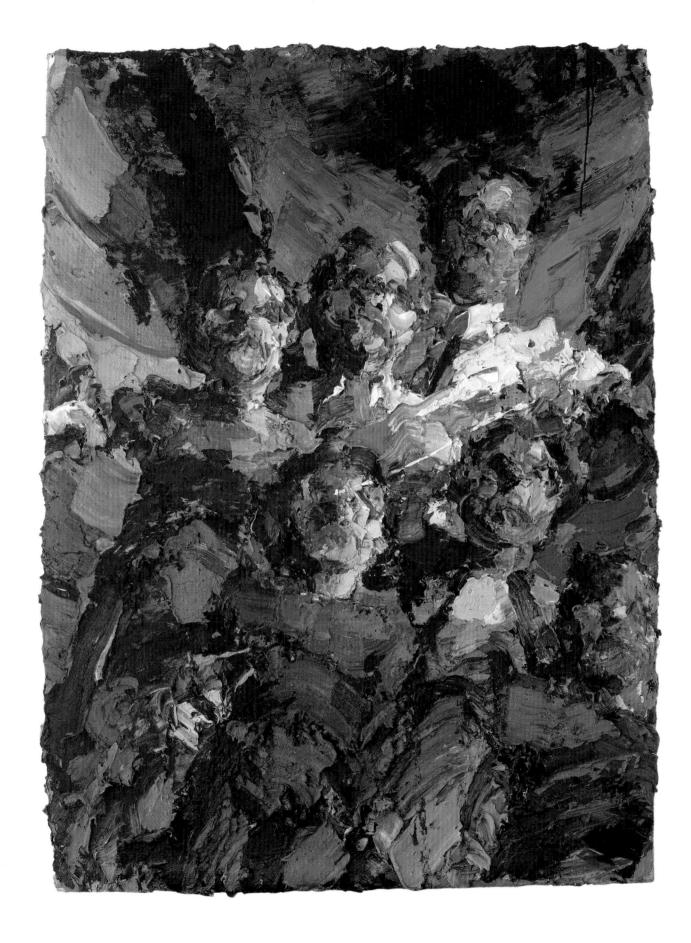

Self
1999
Graphite on paper
11 × 8 ½ inches
Artist's collection

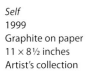

Self
1999
Graphite on paper
11 × 8½ inches
Artist's collection

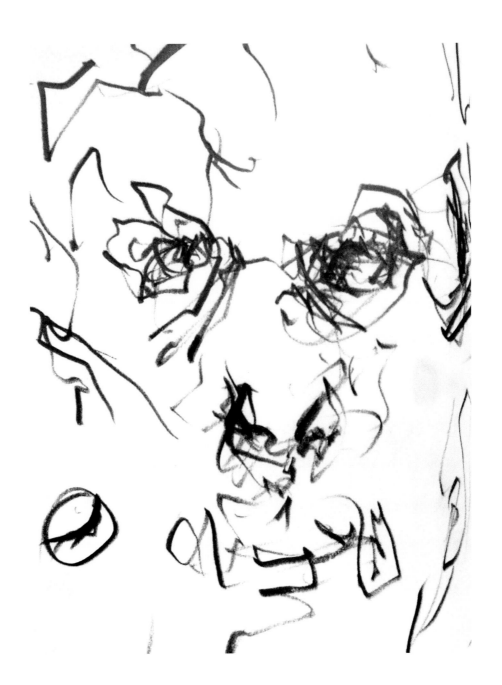

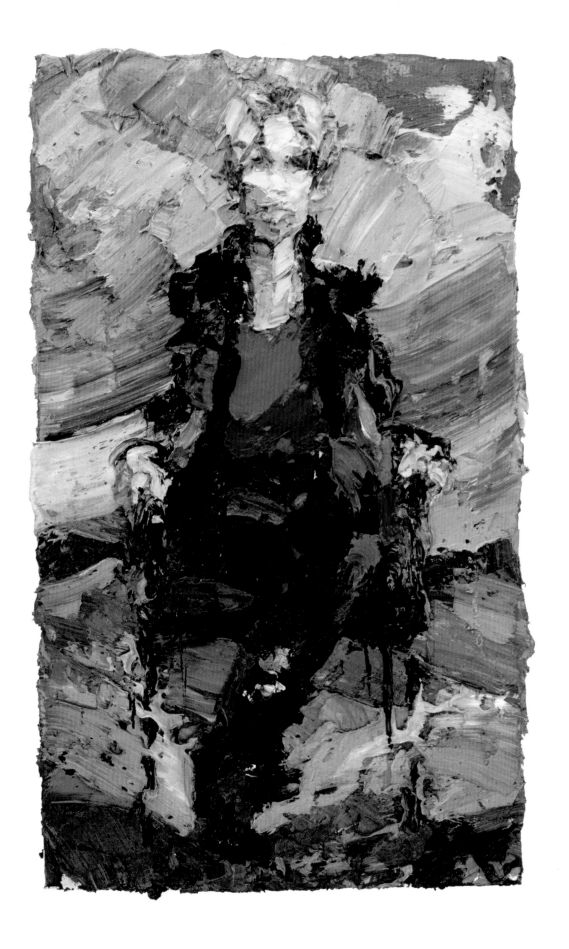

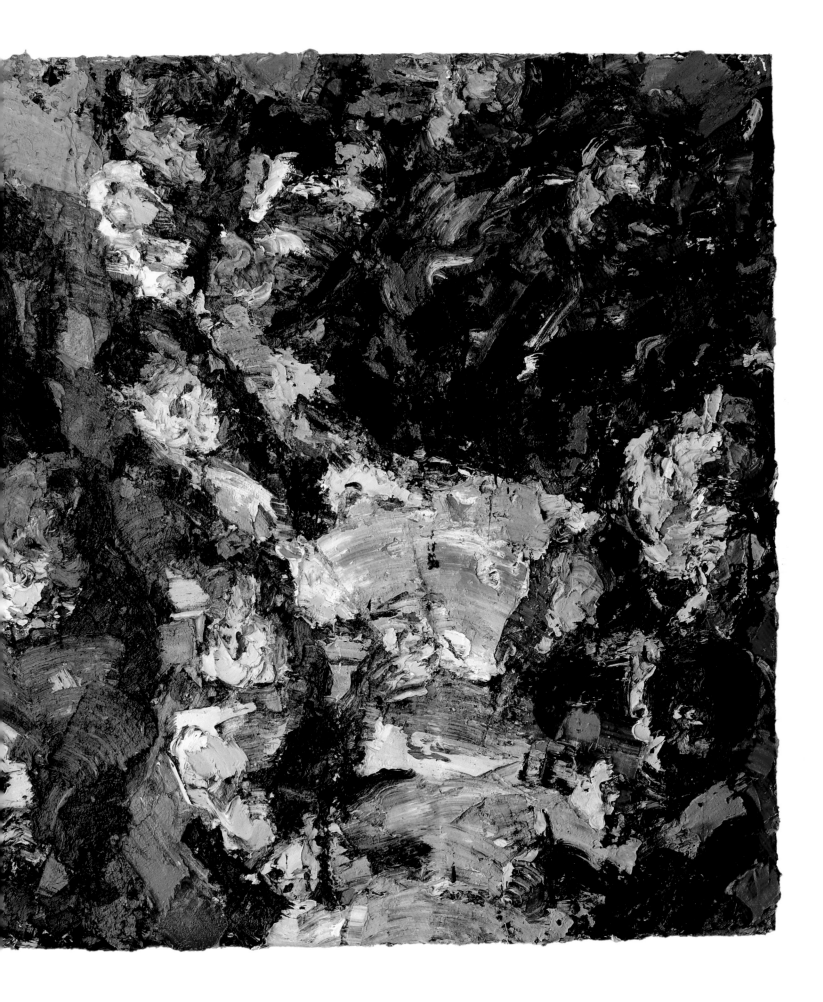

Altie Rodal
2004–06
Oil on cotton
28 × 16 inches
Private collection,
Berel and Alti Rodal

OPPOSITE
Berel Rodal
2002–03
Oil on cotton
28 × 16 inches
Private collection,
Berel and Alti Rodal

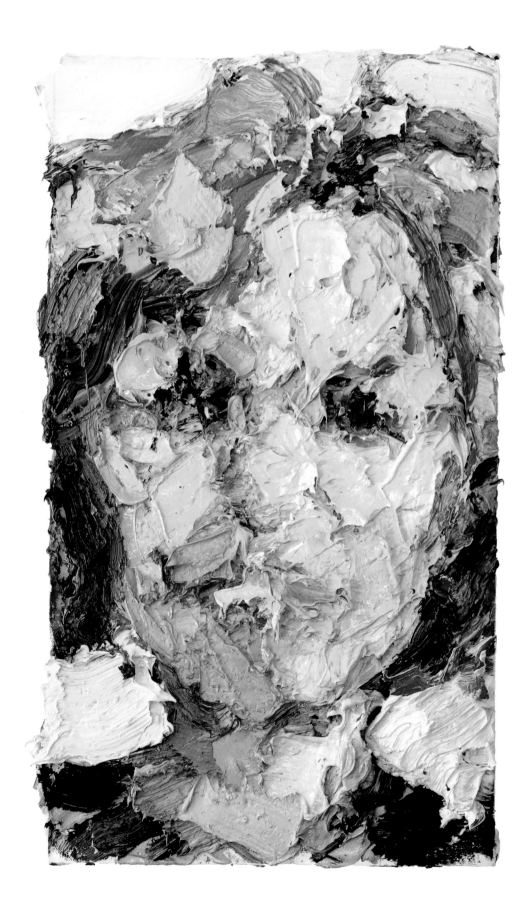

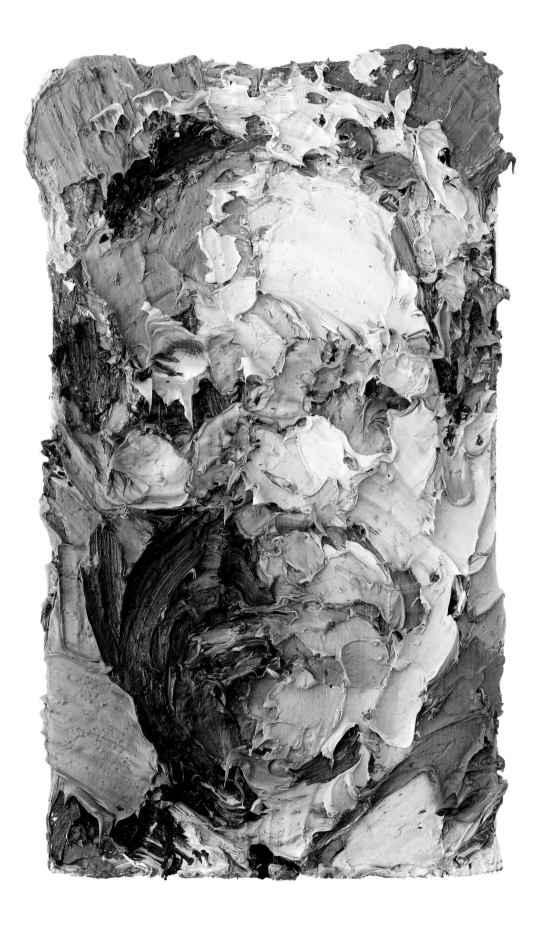

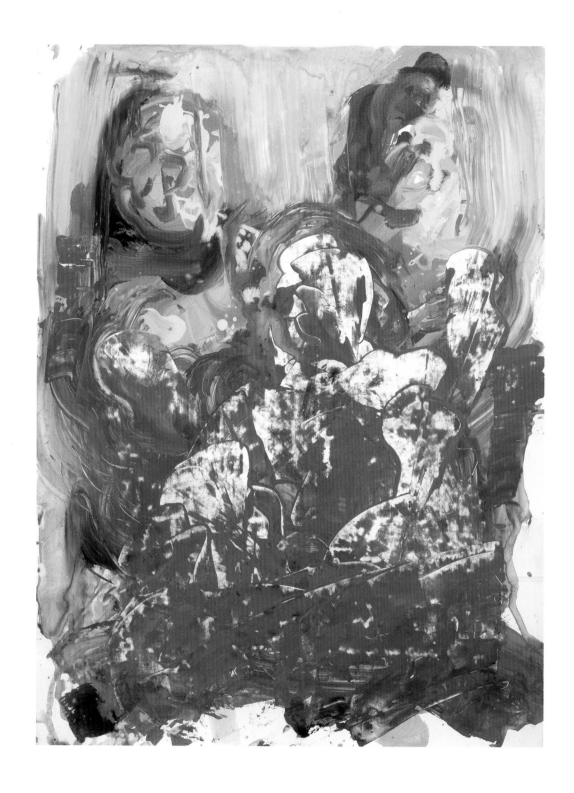

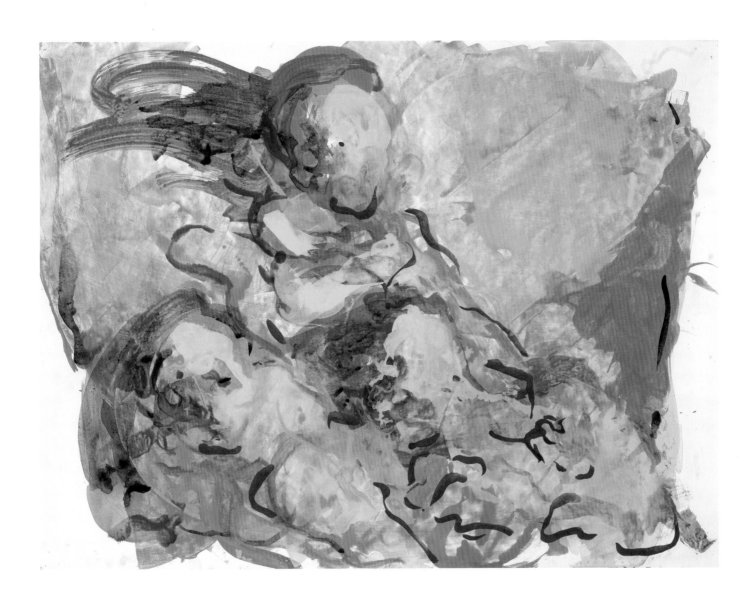

OPPOSITE
Study for
Burning House
2005
Acrylics
Pigments and
charcoal on paper
30 × 21 inches
Artist's collection

ABOVE
Study for
Burning House 003
2005
Acrylics
Pigments and
charcoal on paper
21 × 30 inches
Artist's collection

Strings
2005
Oil on cotton
71 × 81 inches
Artist's collection

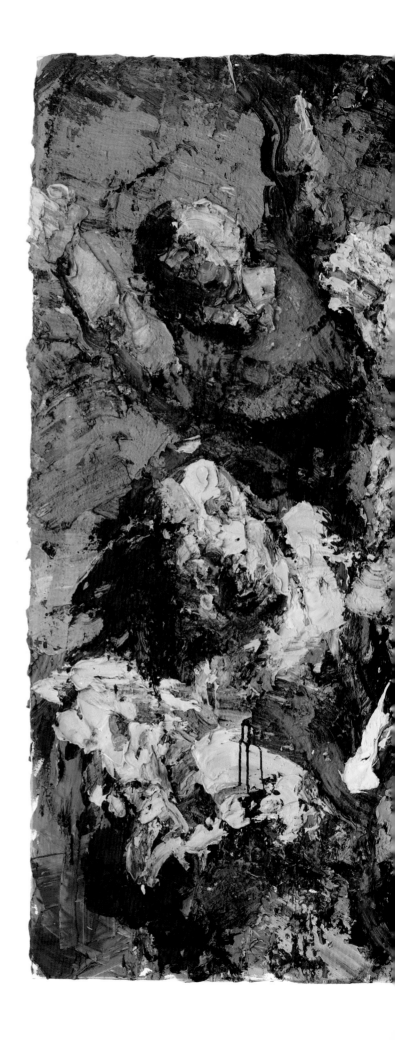

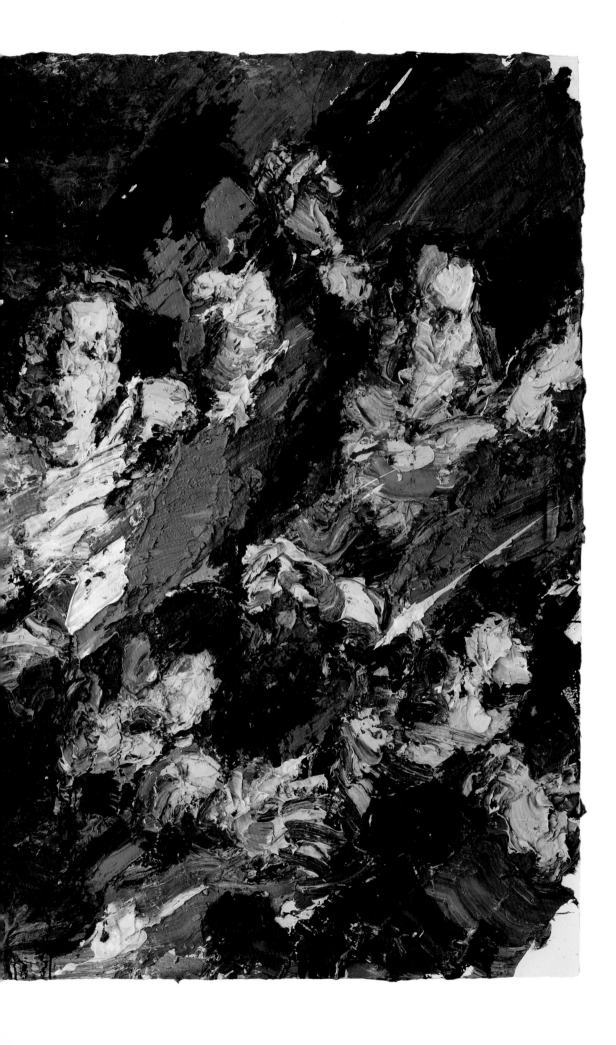

128

Cherry Pickers
2005
Oil on cotton
74 × 58 inches
Collection Joachim Graf,
Essen, Germany

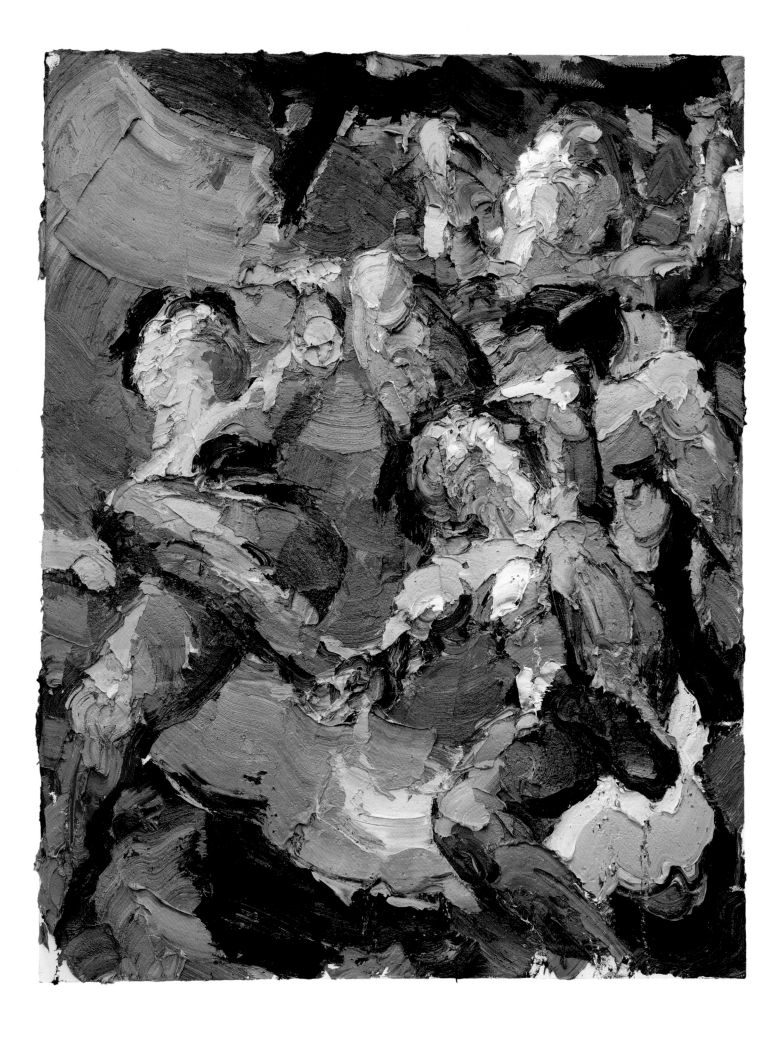

Portrait LAR
2005
Oil on cotton
28 × 16 inches
Rosenwald collection,
New York

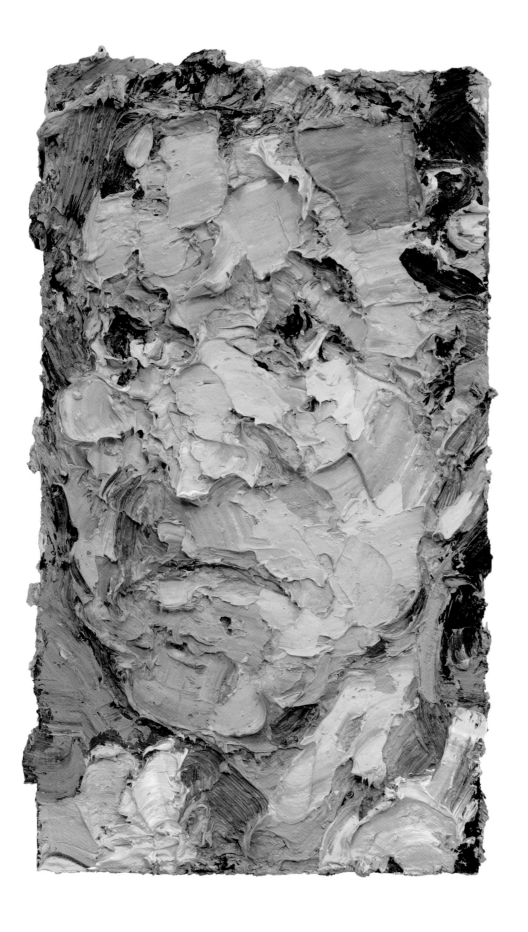

Running with Fools
2005–06
Oil on cotton
58 × 75 inches
Artist's collection

The Perrin Sisters
(Elizabeth)
2006
Oil on cotton
28 × 16 inches
Private collection,
New York

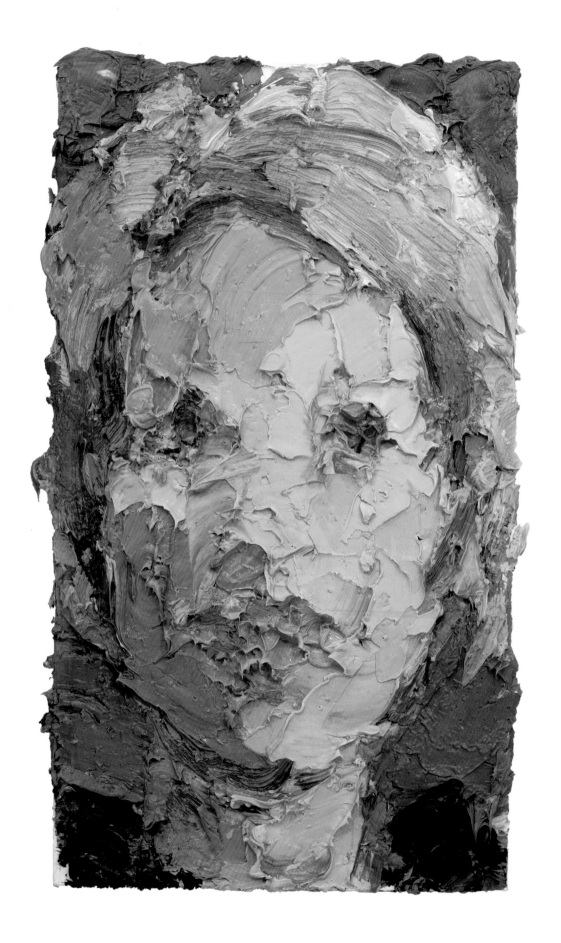

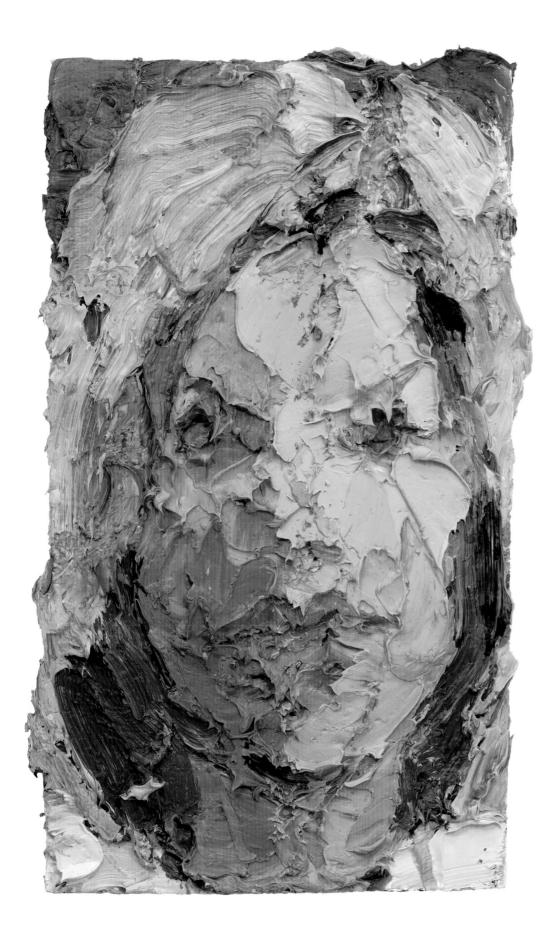

The Perrin Sisters
(Erica)
2006
oil on cotton
28 × 16 inches
Private collection,
New York

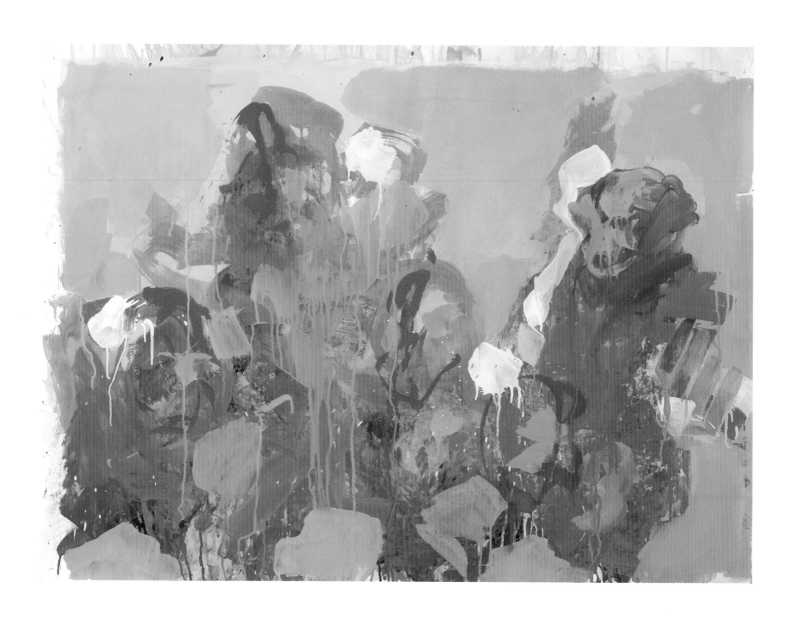

Above and Below 1
2006
Mixed media on paper
38 × 52 inches
Artist's collection

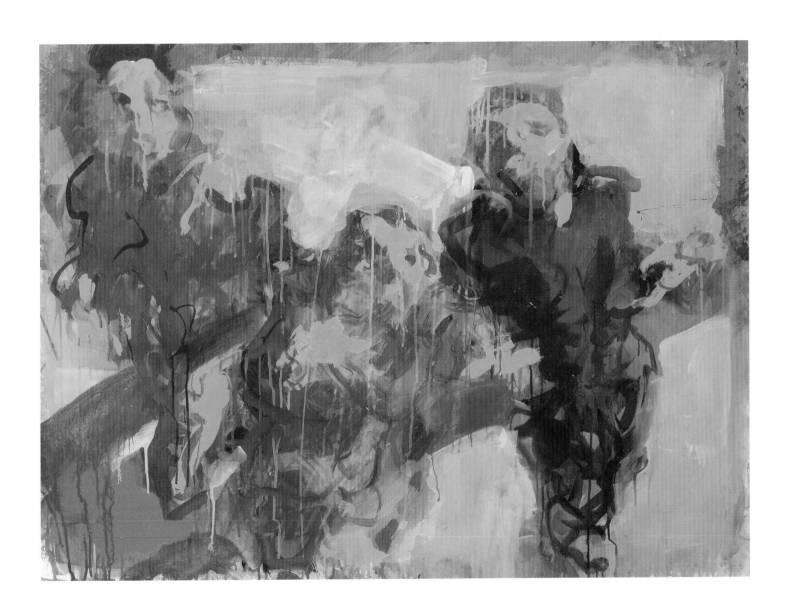

Above and Below 2
2006
Mixed media on paper
38 × 52 inches
Artist's collection

Coming Home
2006
Mixed media on paper
38 × 52 inches
Artist's collection

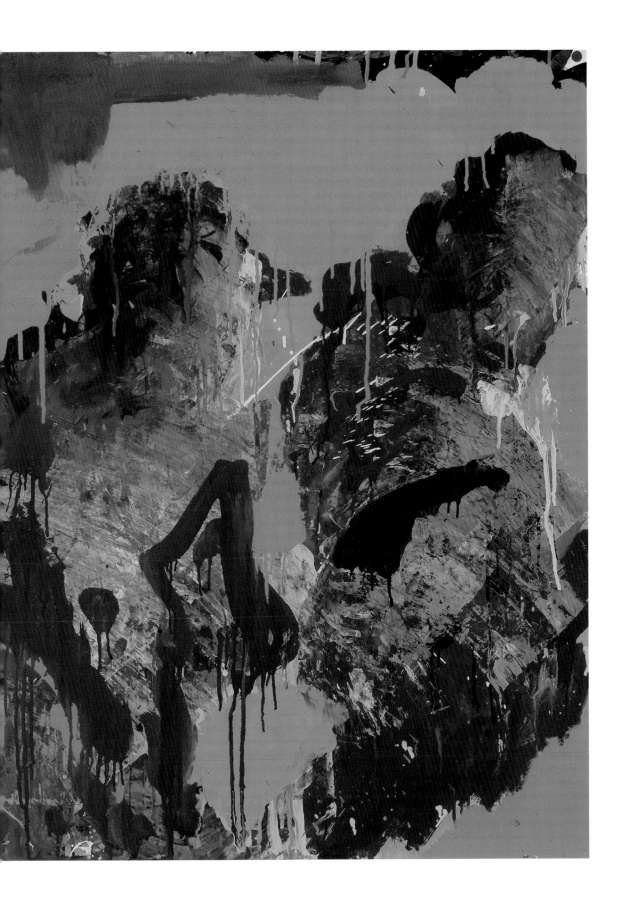

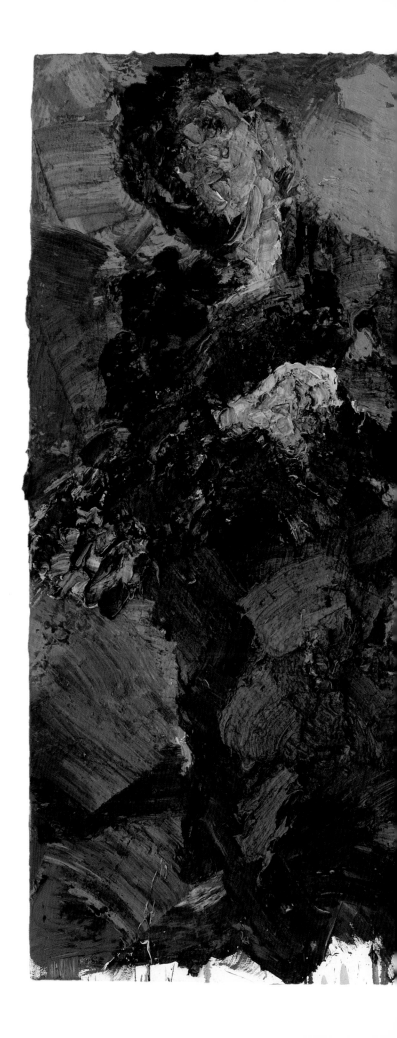

Coming Home
(sacra conversazione)
2007
Oil on cotton
58 × 75 inches
Artist's collection

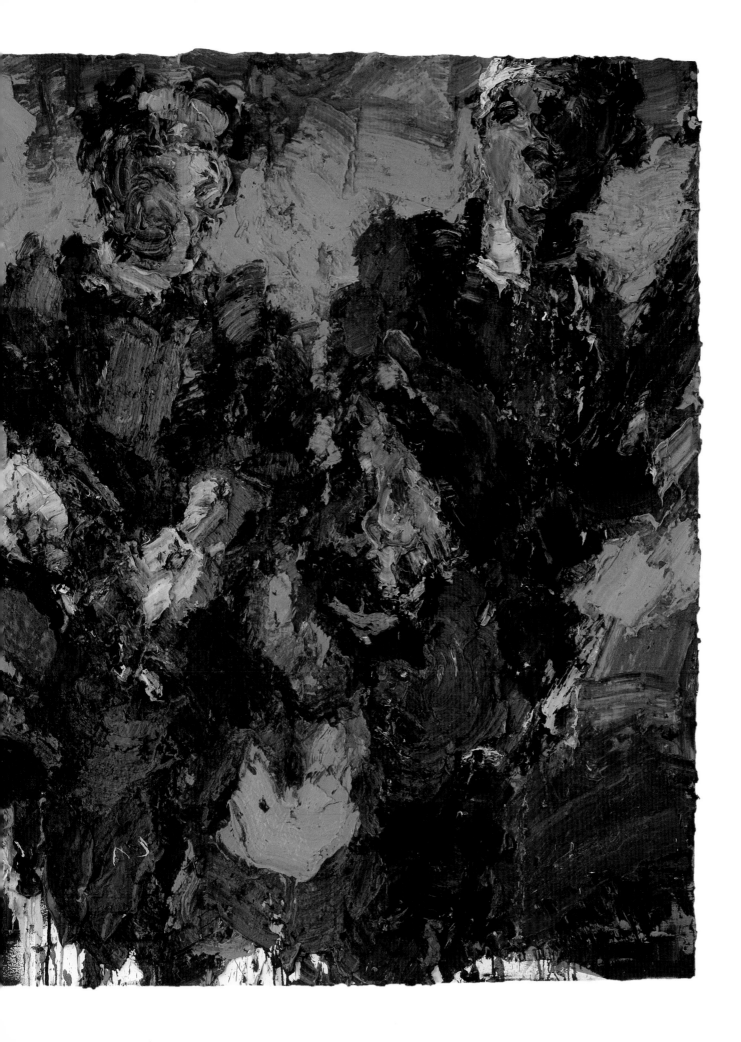

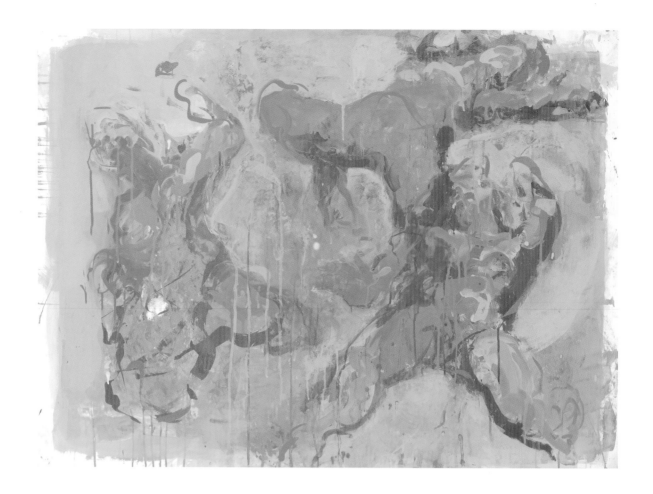

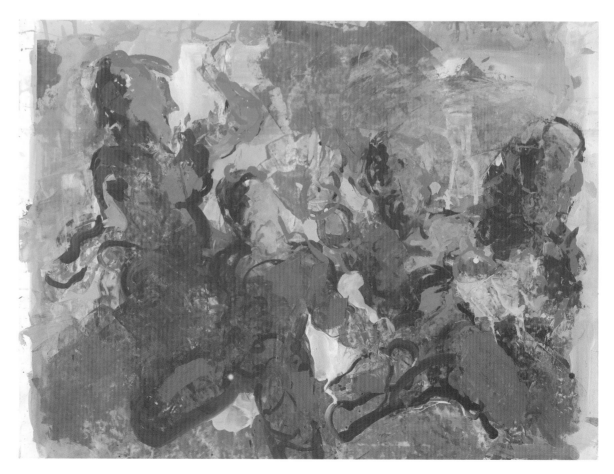

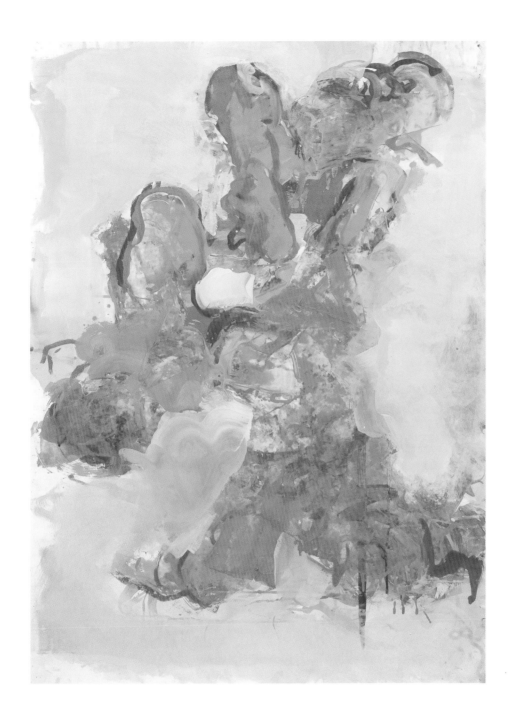

Figure Study 3
2006
Mixed media on paper
52 × 35 inches
Artist's collection

**OPPOSITE
TOP TO BOTTOM**

Figure Study 2
2006
Mixed media on paper
38 × 52 inches
Artist's collection

Figure Study 1
2006
Mixed media on paper
38 × 52 inches
Artist's collection

Aaron
2006
Oil on cotton
28 × 16 inches
Braunstein collection

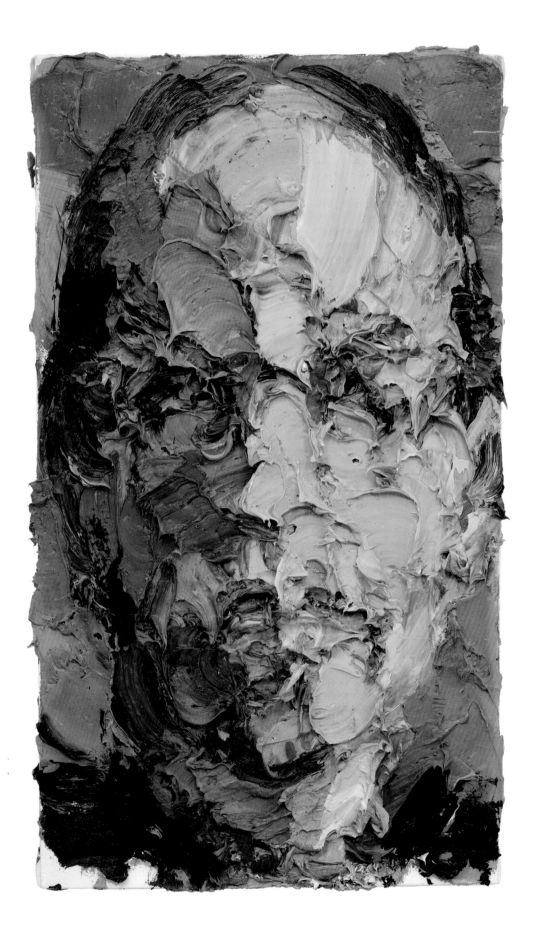

Gravediggers
2007
Oil on cotton
61 × 51 inches
Artist's collection

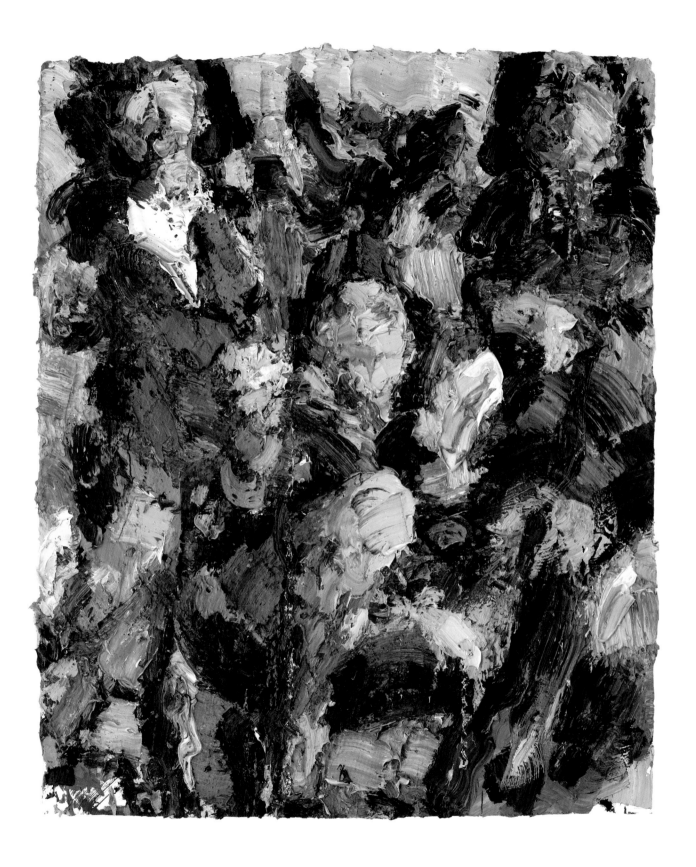

Outdoor Weekend
2007
Ink
Acrylics
Pigment and watercolor on
paper
30 × 22 ½ inches
Artist's collection

OPPOSITE
Shadow Boxing Again
2007
Acrylics
Pigment and watercolor on
paper
30 × 22 ½ inches
Artist's collection

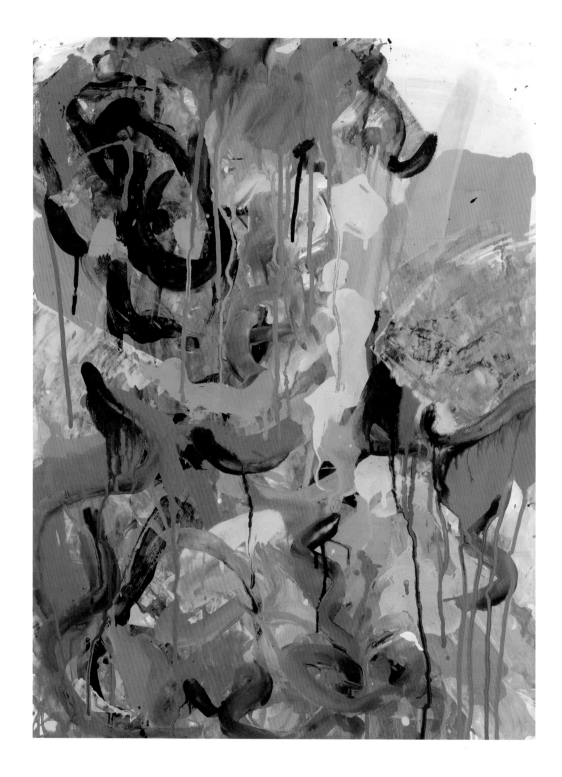

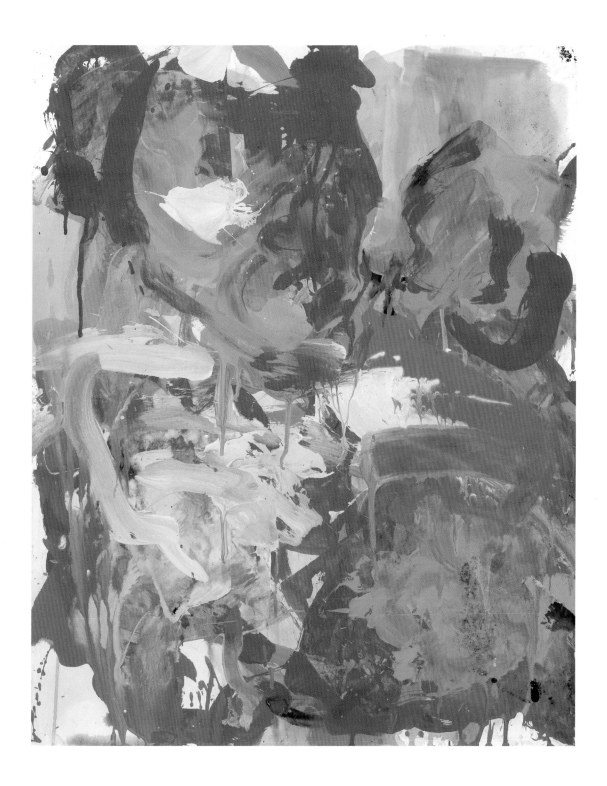

LEFT TO RIGHT
TOP TO BOTTOM

Weekday Dialogue 1

Weekday Dialogue 2

Weekday Dialogue 3

Weekday Dialogue 4

Weekday Dialogue 5

Each: 2007
3-color stone lithograph
30 × 22 inches
Artist's collection

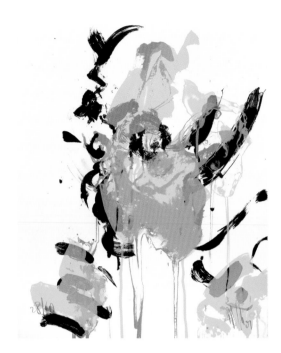

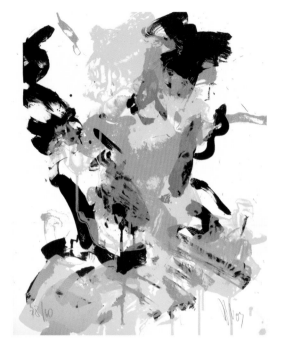

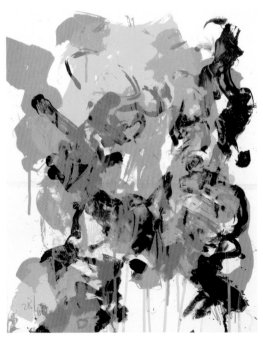

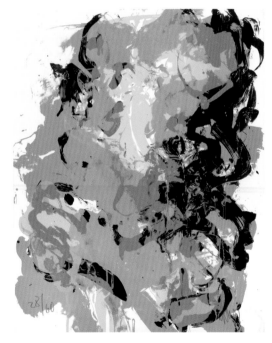

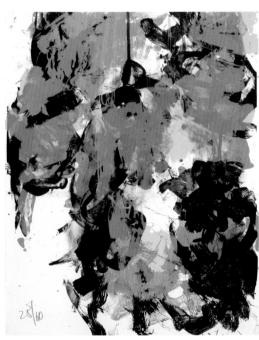

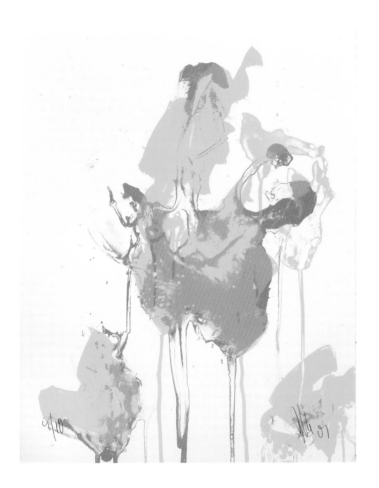

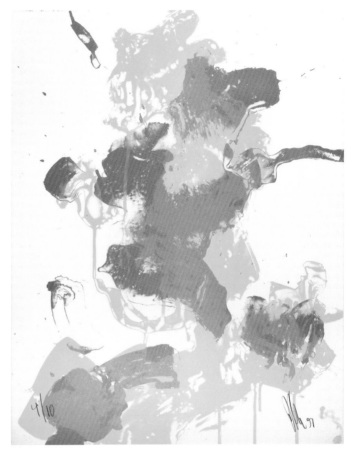

Weekend Conversation 1
2007
2 color stone lithograph
30 × 22 inches
Artist's collection

Weekend Conversation 2
2007
2 color stone lithograph
30 × 22 inches
Artist's collection

Greasy Morning
2007
Oil on cotton
49 × 65 inches
Collection Joachim Graf,
Essen, Germany

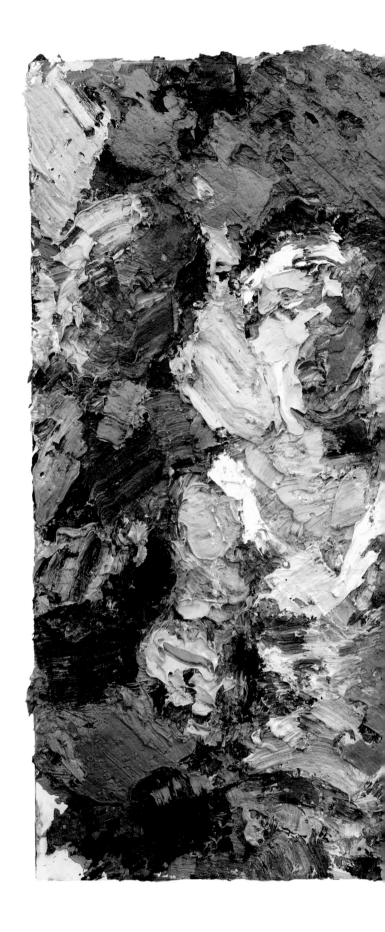

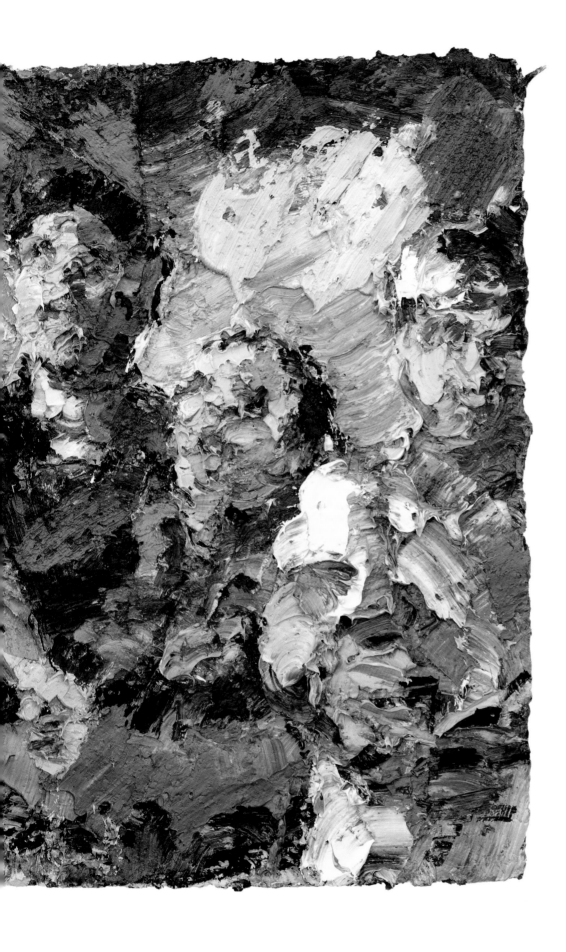

Chopsticks and Arizona
2007
oil on cotton
58 × 75 inches
Collection Joachim Graf,
Essen, Germany

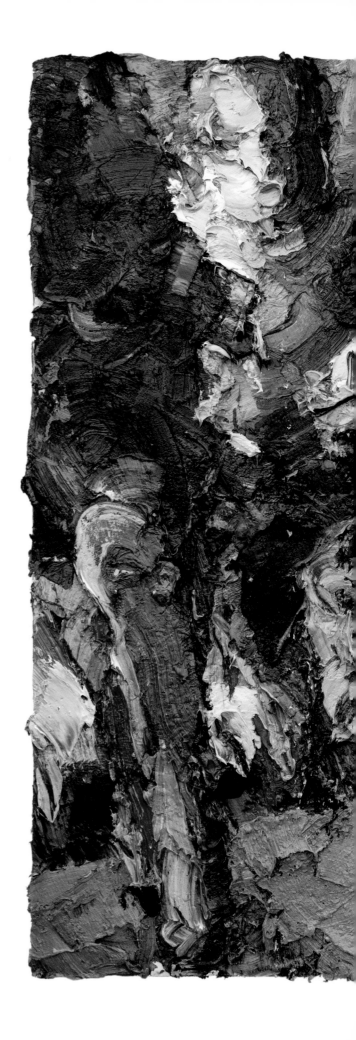

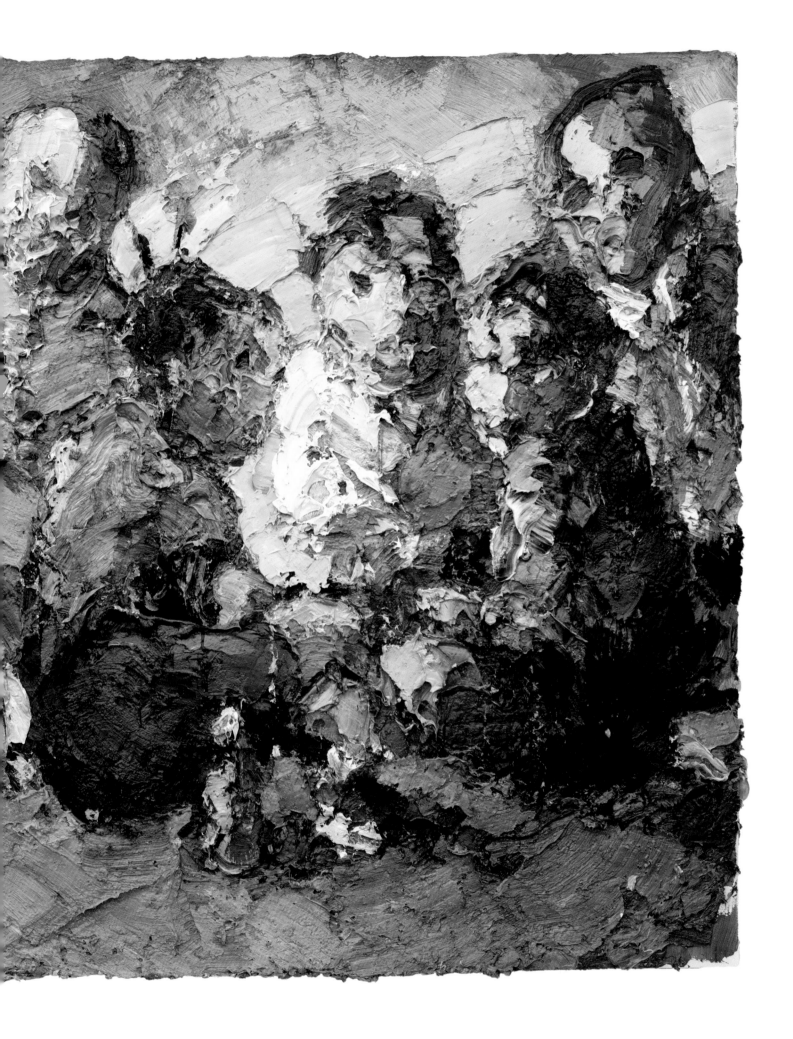

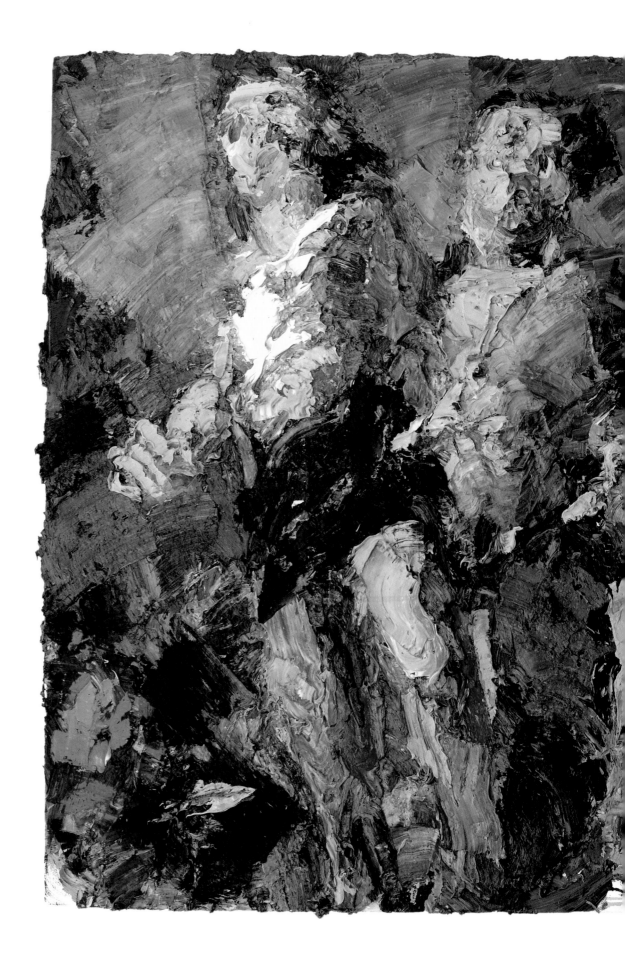

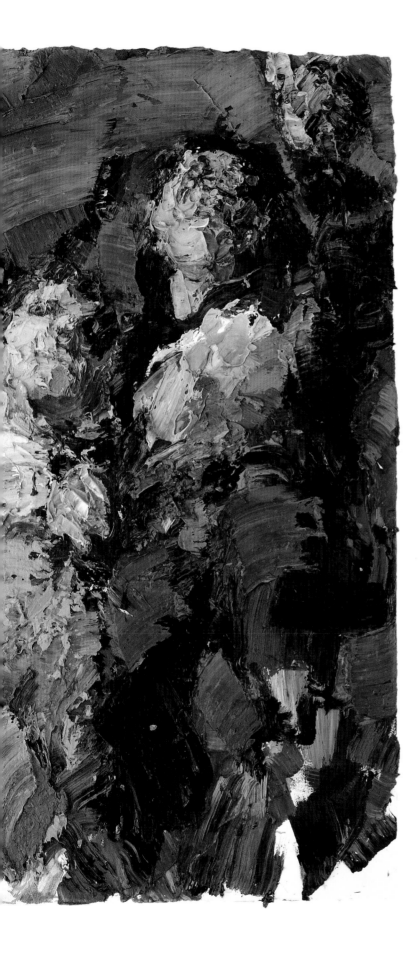

Cold Cuts
2007
Oil on cotton
58 × 75 inches
Artist's collection

PRB (Blue Carpet)
2007
Oil on cotton
58 × 75 inches
Artist's collection

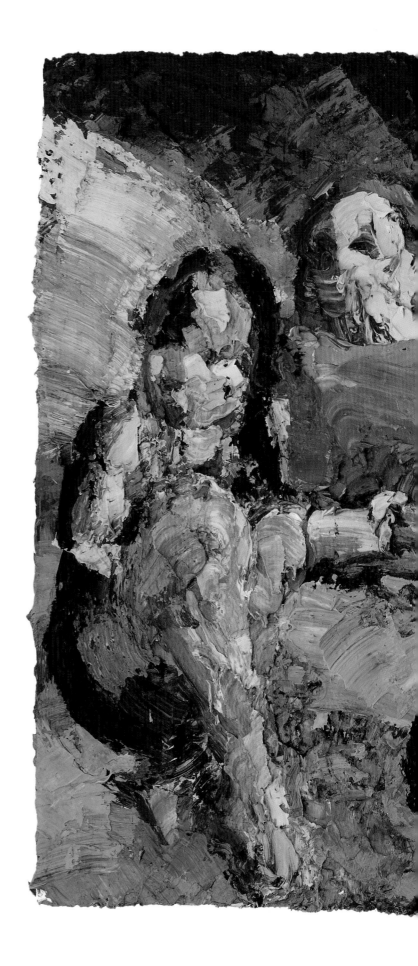

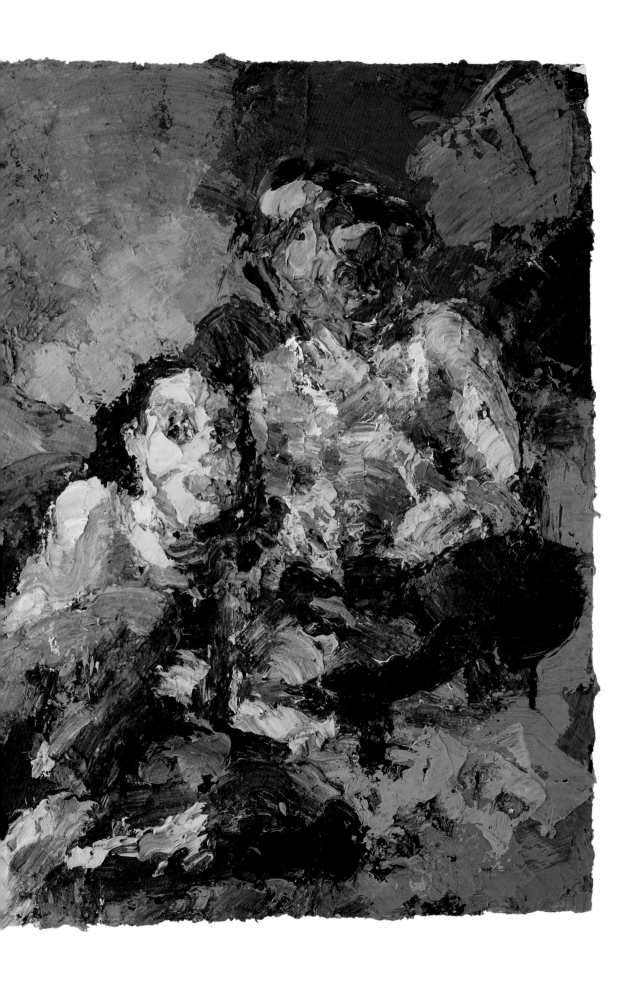

American Pastoral
2008
Oil on cotton
61 × 51 inches
Artist's collection

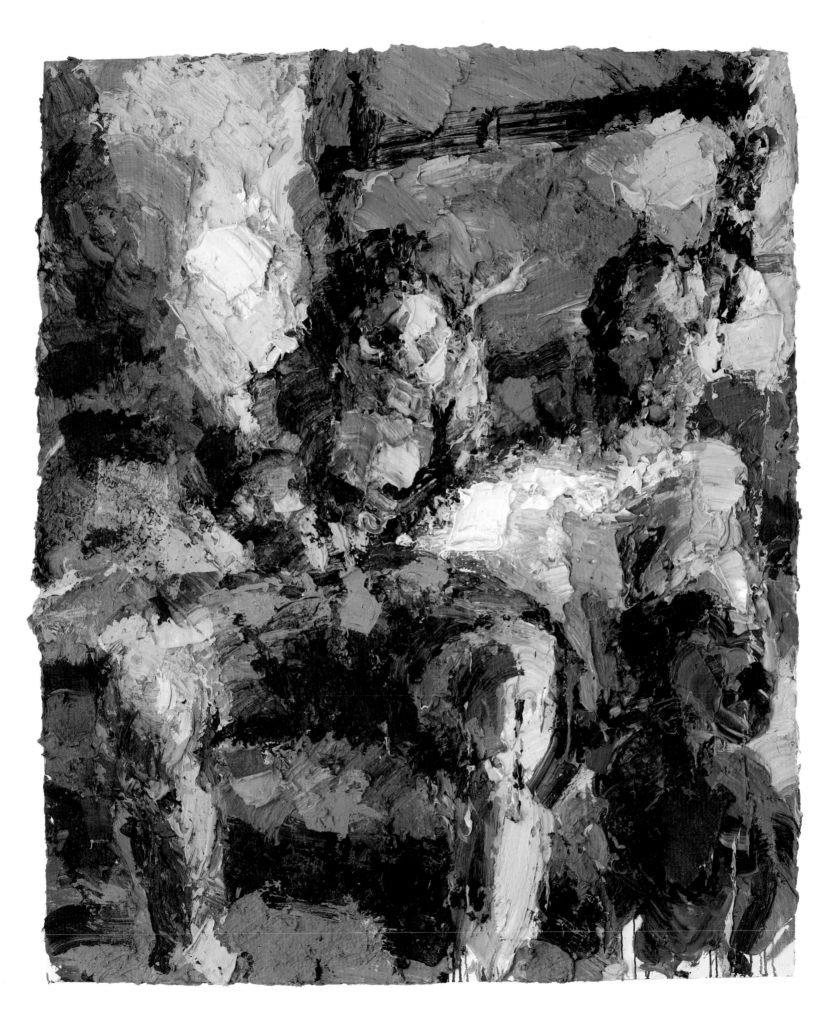

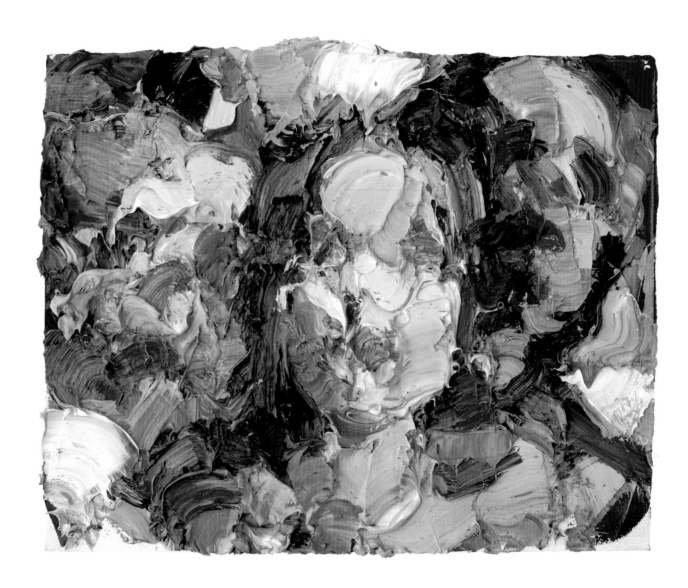

The Guardians
2008
Oil on cotton
22 × 28 inches
Artist's collection

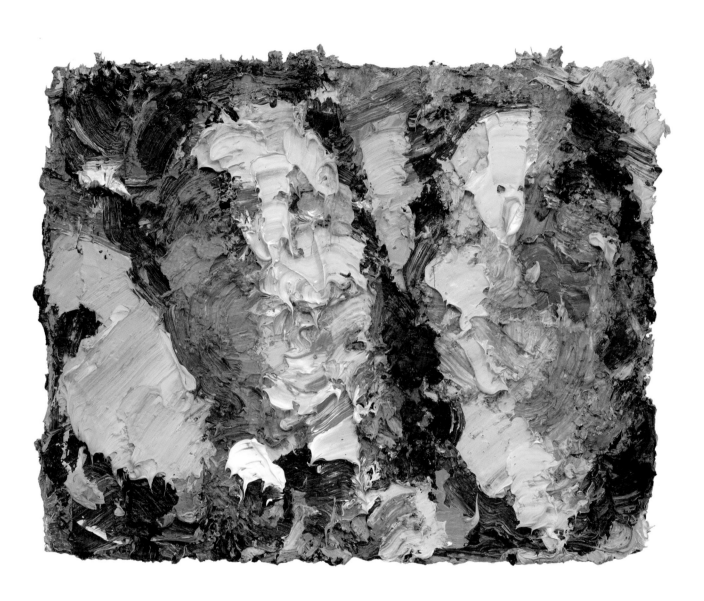

Pink Mirror
2008
Oil on cotton
22 × 28 inches
Artist's collection

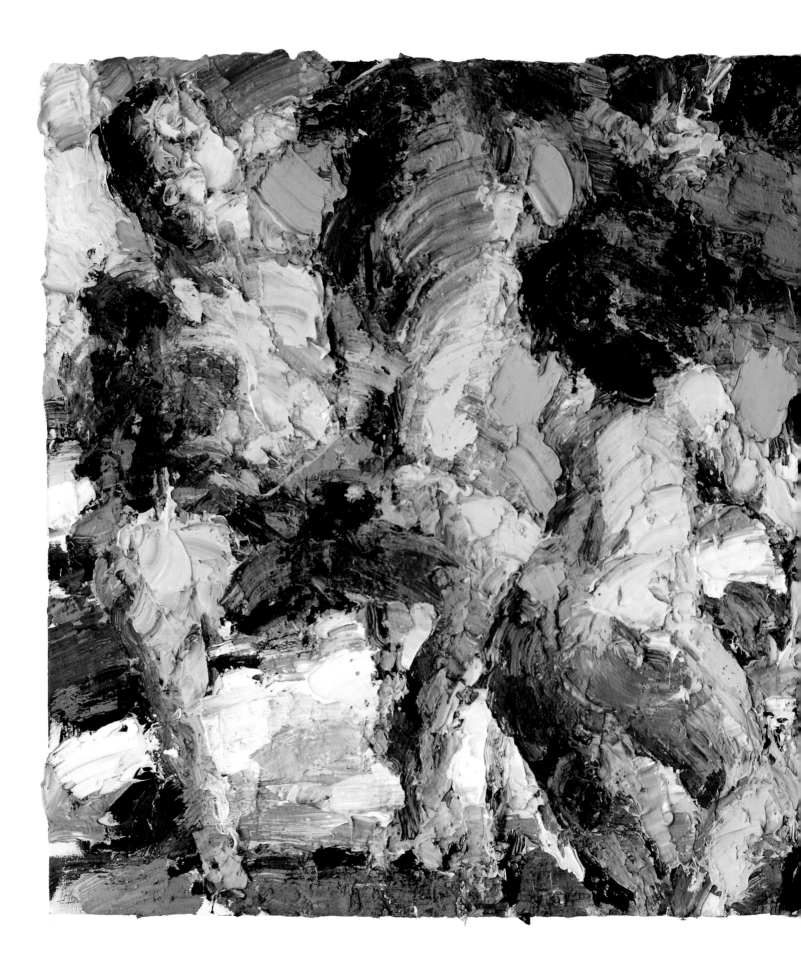

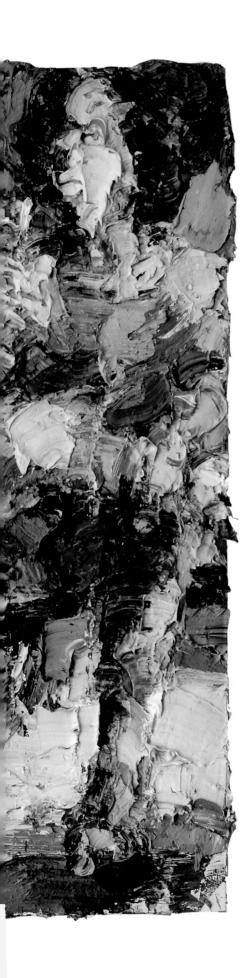

Knights and Nudes
2008
Oil on cotton
58 × 75 inches
Artist's collection

Screen Shot 001
2008
Acrylics, pigment,
and watercolor
on paper
30 × 22 ½ inches
Artist's collection

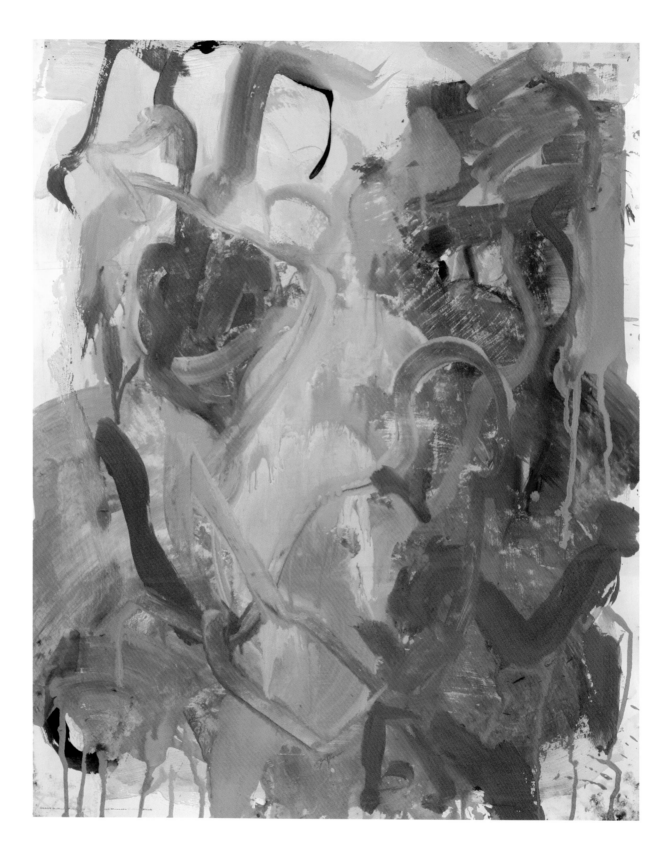

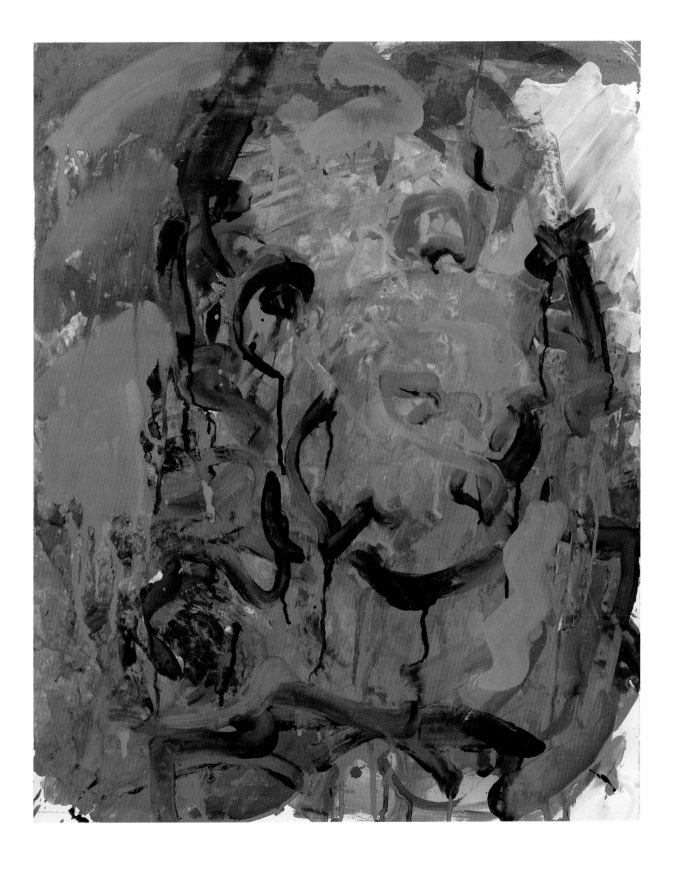

Screen Shot 002
2008
Ink, acrylics, pigment,
and watercolor on paper
30 × 22 ½ inches
Artist's collection

Bryant Park
2008
Oil on cotton
58 × 75 inches
Artist's collection

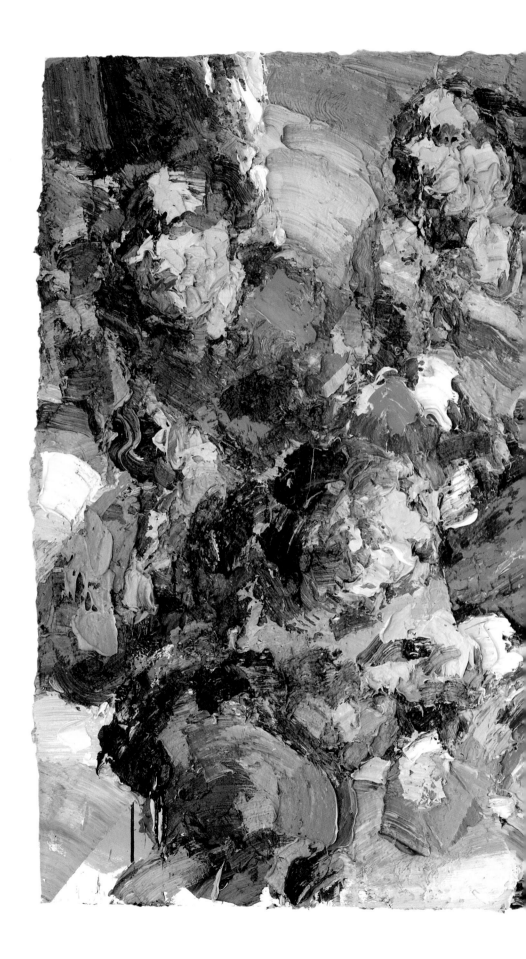

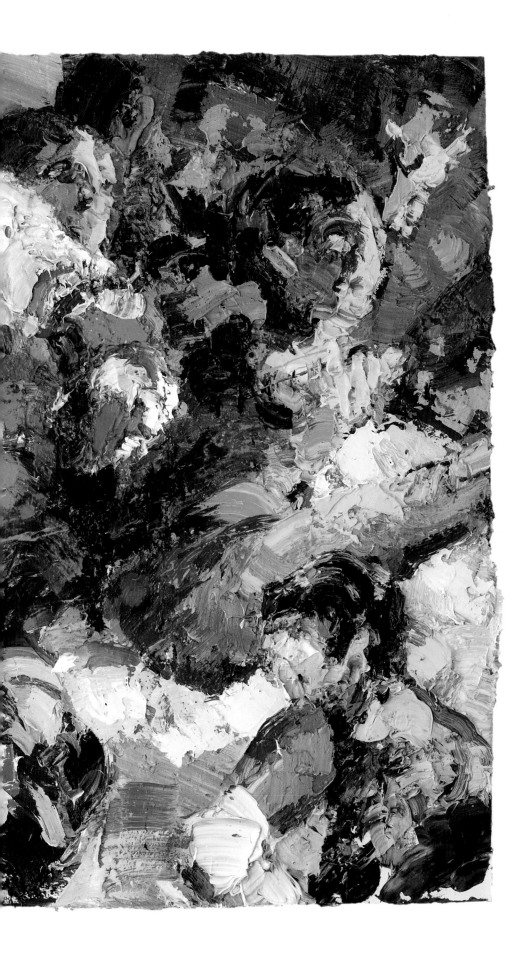

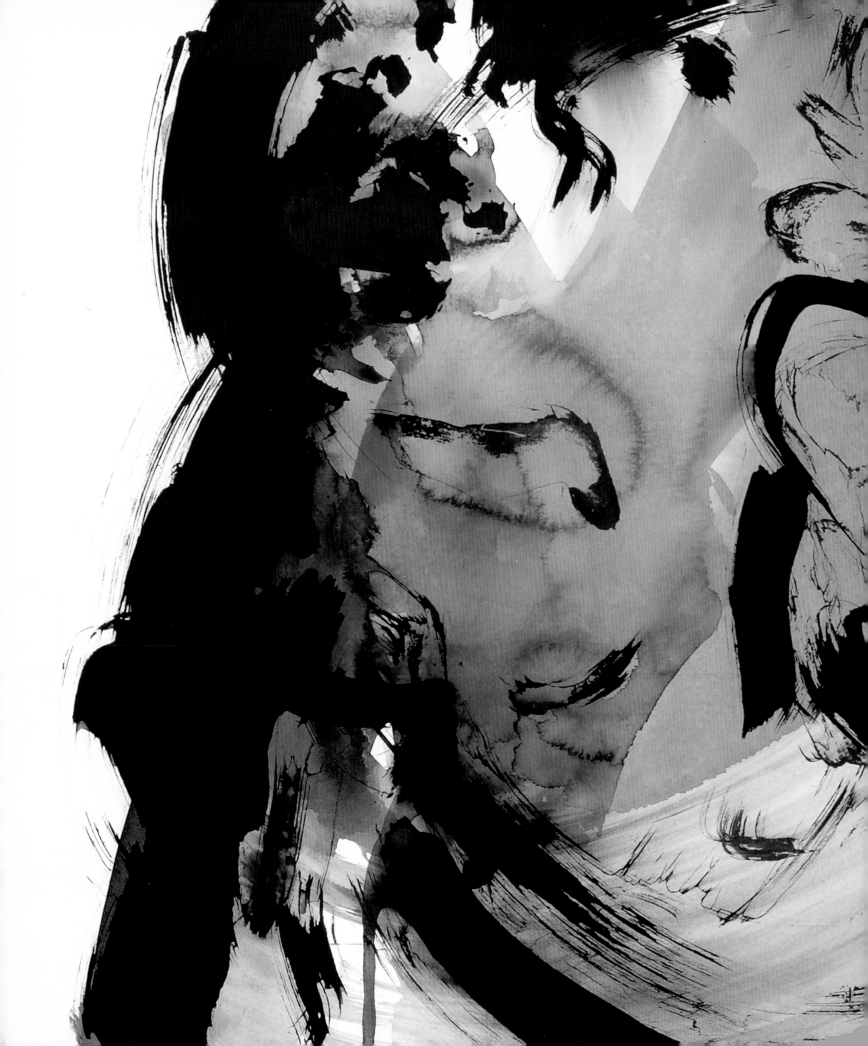

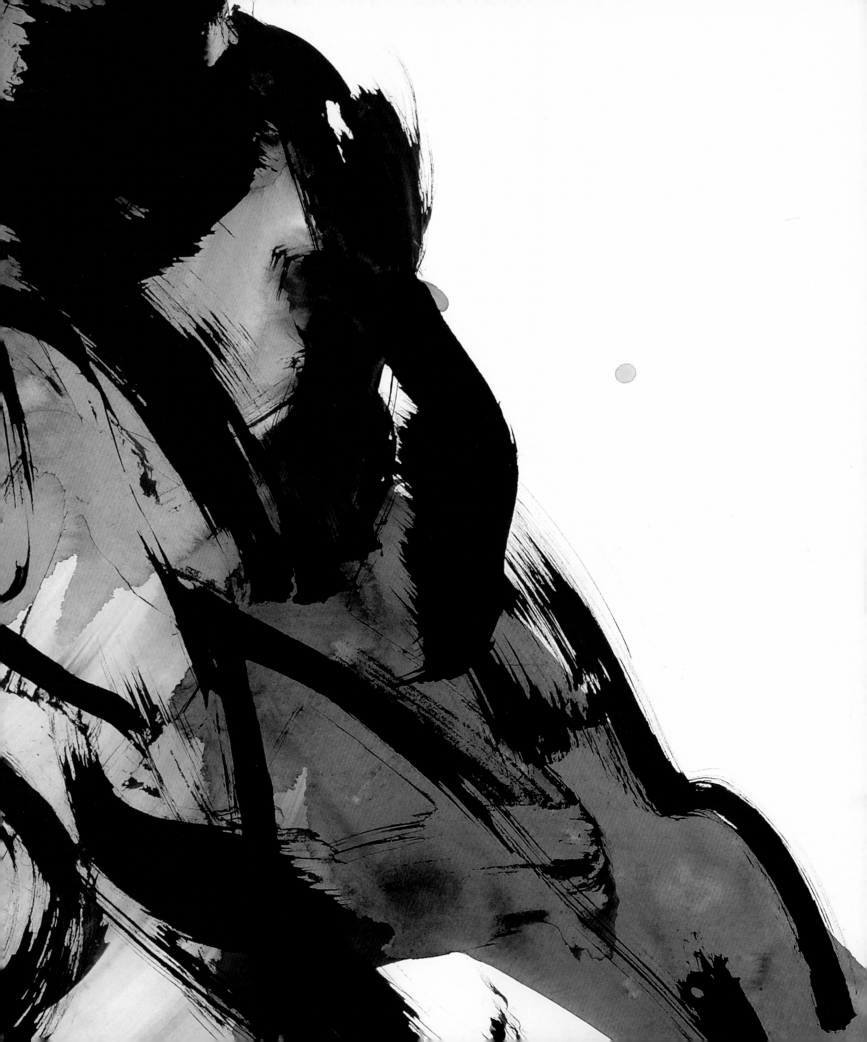

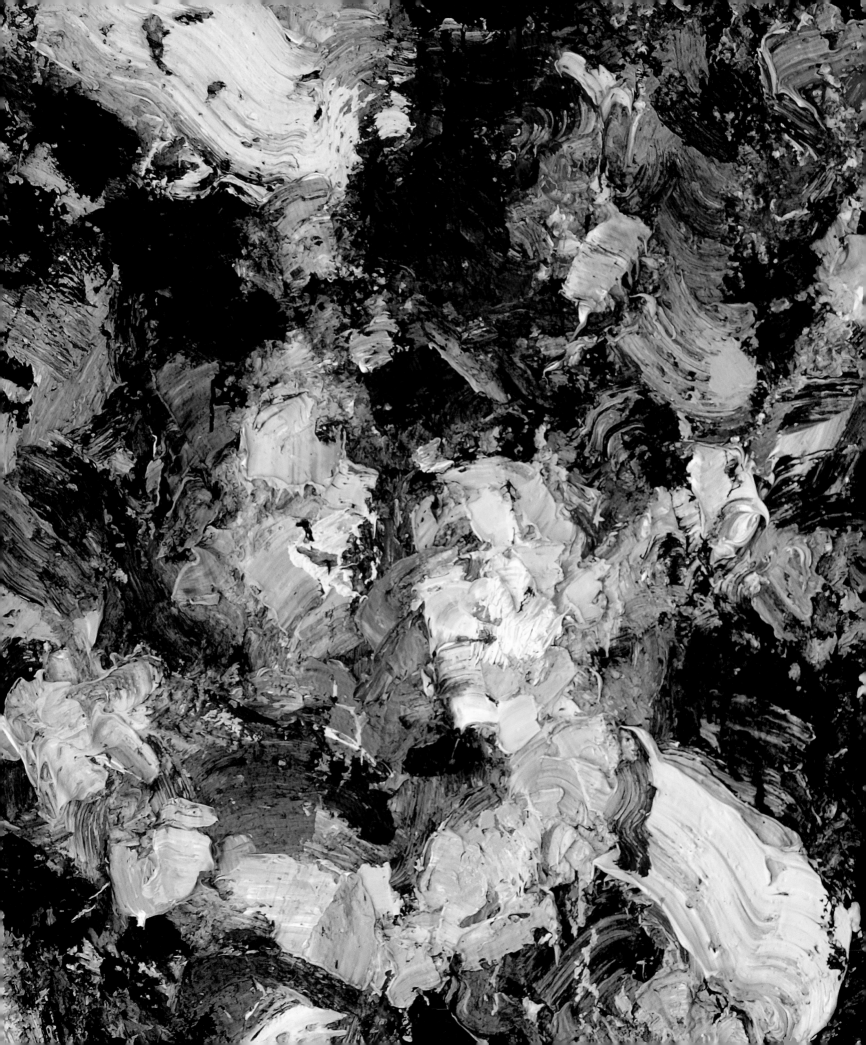